CREATIVE
GRAB
BAG

BOOKS

Cincinnati, Ohio
www.howdesign.com

CREATIVE
GRAB
BAG

inspiring challenges for designers,

illustrators and artists

ETHAN BODNAR

CREATIVE GRAB BAG. Copyright © 2009 by Ethan Bodnar. Manufactured in China. All rights reserved. No other part of this book may be reproduced in any form or by any electronic or mechanical means including information storage and retrieval systems without permission in writing from the publisher, except by a reviewer, who may quote brief passages in a review. Published by HOW Books, an imprint of F+W Media, Inc., 4700 East Galbraith Road, Cincinnati, Ohio 45236. (800) 289-0963. First edition.

For more excellent books and resources for designers, visit www.howdesign.com.

13 12 11 10 09 5 4 3 2 1

Distributed in Canada by Fraser Direct
100 Armstrong Avenue
Georgetown, Ontario, Canada L7G 5S4
Tel: (905) 877-4411

Distributed in the U.K. and Europe by David & Charles
Brunel House, Newton Abbot, Devon, TQ12 4PU, England
Tel: (+44) 1626-323200, Fax: (+44) 1626-323319
E-mail: postmaster@davidandcharles.co.uk

Distributed in Australia by Capricorn Link
P.O. Box 704, Windsor, NSW 2756 Australia
Tel: (02) 4577-3555

Library of Congress Cataloging-in-Publication Data
Bodnar, Ethan.
 Creative grab bag / Ethan Bodnar.
 p. cm.
 ISBN 978-1-60061-147-6 (pbk. with flaps : alk. paper)
 1. Graphic arts. 2. Creative ability. I. Title.
 NC997.B53 2009
 709.2'2--dc22 2008046556

fw media

Edited by Melissa Hill
Designed by Terri Woesner
Production coordinated by Greg Nock

DEDICATION

For Mom and Dad, with much love.
Special thanks to family and friends.

ACKNOWLEDGMENTS

To make a book like this one involves so many people; everybody that helped to make *Creative Grab Bag* made it a remarkable experience. Without them, you would not be able to witness the visual brilliance that comes about when artists are challenged to explore their creativity. Thank you to everyone who came along for the journey.

First, thank you to my parents, Debbie and Tom Bodnar, for everything that they have provided for me throughout my life and for all of their love. Thanks to my brothers, Nathaniel and Sean, for making life an ever-changing adventure full of love.

Thank you to all of the talented artists that contributed to this book. It was a great pleasure and honor to work with you.

The first person that made this publication a reality is Megan Lane Patrick, the senior editor at *HOW* Magazine and Books. She emailed me back and said, "I would definitely be interested in seeing a full proposal. This is a pretty cool idea." Thanks to Jane Friedman, editorial director at F+W Media, for going through the contract process with me. Jane handed the project off to Amy Schell who acted as my editor for the first part of the project; she assisted in getting the book off to a great start. For the second part of the book, I worked with Melissa Hill as my editor. She provided brilliant feedback and was just the kind of person I wanted and needed to guide me through the process. Thank you, Melissa and Amy. Thanks to Terri Woesner for the design of this book. Thanks to everyone else at F+W Media and HOW Books.

Thanks to Mary Donnarumma Sharnick for introducing me to the publishing process; I wish her much success in her literary career. Thanks to my art teacher and advisor, Rusty Brockmann, and my other art teachers, Lincoln Turner, Robert Cutrofello and Andrea Carter. Thanks to Kate Bingaman-Burt for being there from the start of my adventure in graphic design. Thanks to everyone at Chase Collegiate School and the Hartford Art School.

A special and heartfelt thanks to my family and friends: You are the ones that I am grateful to spend my life with, and you're all amazing.

ABOUT THE AUTHOR

Ethan Bodnar is a graphic designer, artist and student who lives and works in the United States. He attends the Hartford Art School where he is working toward a Bachelor of Fine Arts in Graphic Design. As an Eagle Scout, Ethan is committed to community and leadership values in his work and life.

He graduated from Chase Collegiate School and was awarded the Alberta C. Edell Head of School Award for outstanding accomplishments. He received the Henry Wolf Award, a Worldstudio AIGA Scholarship, in 2008. He has experience as an intern working on design and business strategy, as a web site designer and as a theatrical lighting designer.

Ethan has been creating graphic design work for several years. He is currently studying and practicing design and art in college, where his skills and interests are continuing to expand.
See his work at www.ethanbodnar.com/portfolio.

The Blog has been Ethan Bodnar's online publication since 2006. It covers topics of design, technology and life. Here Ethan shares with others and documents ideas, stories and thoughts. It offers readers an opportunity to start a conversation and follow his education in the years to come.
Visit him at www.ethanbodnar.com.

He plans to use creative thinking to have a positive impact on people from communities around the world, both large and small. He wishes to imagine, learn, grow and explore the world and to connect with people sitting next to him and across the globe. Ethan gets inspiration from the beauty of the life he leads and those around him. Ethan enjoys eating blueberry pancakes, making art, dreaming of the future and being with friends and family.

ETHAN'S THOUGHTS ON CREATIVITY

"Everybody is born an artist; I am pleased that I have decided to stay one. As I child, I remember my mom would always have crafts for us to do, always something out of the ordinary. Eventually, I found graphic design. At first, I started exploring the design community online, which led to creating my own design work. Design has introduced me to art as a whole and has shown me what creative thinking can do. Design and creativity are what my life is about, and I couldn't be happier."

TABLE OF CONTENTS

ILLUSTRATION

MIXED MEDIA

PACKAGING DESIGN

VISUAL STORY-TELLING 👁

CREATE A COMIC STRIP

CREATE AN ANIMATION

DESIGN A CHARACTER

INTRODUCTION

In life, you don't always know what is going to happen next. You have to work with what you're dealt. You learn to try something new and make compromises. When you try something new, you can learn from your experience. We all embark on a process of discovery and exploration in life. The artists in this book have taken this voyage even further. Their boldness has created a book filled with creativity and imagination. It is a book about trying something new and opening up to different ideas; it's about gaining respect for new challenges. This is a book of visual creations from people around the world that have come together through the exploration of the unfamiliar to create something beautiful. That exploration of new ideas is what this book celebrates.

There was a point in my life when I was starting to take a real interest in the art and design community, and I decided that I would like to make a book, a tangible publication that you and I could hold in our hands. The idea came gradually: I would create a book that featured work by artists who had pulled a task from a grab bag. Once I figured out the premise of the book, I sent invitations for contributions for the book to creative people whose work I enjoyed. The artists I selected are from all over the world. Some are well known and some are up-and-coming artists. Each of them offer different styles of work in a variety of mediums. Soon, people wrote back to me and expressed their interest. That was an amazing experience, and I was a bit surprised by their enthusiasm because I didn't have a publisher yet. Plus, this project would require contributors to do additional work; they could not just spend a couple minutes collecting past work to send. Each of them received a creative task picked at random from the Creative Grab

Bag. Since the book is about learning to do new things with your creativity and exploring new ways of expressing yourself, the creative task couldn't be from their current field of work. Furthermore, I asked each artist to also contribute a piece of their work that comes from their area of expertise, allowing them to showcase the creativity in their day-to-day work.

During the project, I was motivated by communicating with people whose work I respected and enjoyed, and by the idea of the final product—their work in the book I was creating. They were successful in becoming more in tune with their creative spirits and channeling their artistic abilities in a new manner to create this book. It's an honor, and I thank every single one of them for their creativity and diligence. Their excitement and respect for the idea behind the book is what kept me inspired to complete this work.

Making a book is a wonderful thing; it is like nothing else. To me, books are something special, because viewing artwork on printed pages offers a magical feeling and viewing experience. I look forward to flipping through the pages and viewing what I have spent a year and a half of my life creating, the culmination of the dedication and passion that everyone contributed to the book. It's a remarkable and beautiful experience, and it is one that I am pleased to share with you. Think creatively and explore.

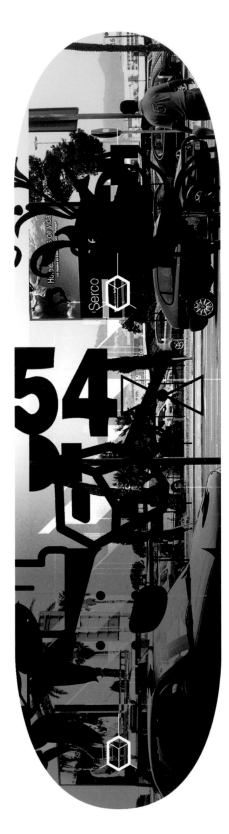

Apartm

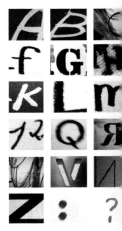

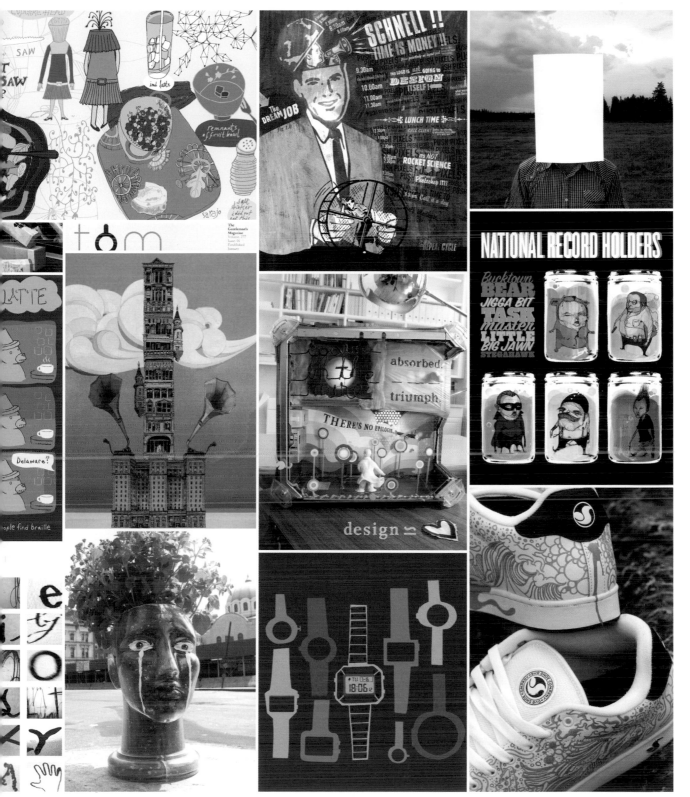

CREATE A COLLAGE

BRYONY GOMEZ-PALACIO AND ARMIN VIT

▶ UNDERCONSIDERATION LLC
www.underconsideration.com

UnderConsideration LLC provides creative services for corporate and brand identity work, as well as full development of printed and digital matter, through consistent management, careful attention to detail and consideration for each project's requirements and context. Bryony Gomez-Palacio and Armin Vit run UnderConsideration. Each has a decade of experience in various disciplines, including corporate and brand identity, annual reports, business collateral, web design and programming, packaging and magazine and book design. UnderConsideration also maintains and publishes a network of online destinations like Speak Up, Brand New, Quipsologies and The Design Encyclopedia.

"One of the goals of this book is to take designers out of their comfort zone and, for us, finding the time to create a collage within our day-to-day operations—which include, but are not limited to, designing on the computer, replying to and composing e-mails and writing and taking care of our one-year-old daughter—proved to be, well, uncomfortable. It is rare to slow down and do a meticulous exercise that is both therapeutic and creative, so this collage of found letters in our stacks of magazines was just what we needed as a distraction. Each approximate square is made up of the same letter in different styles, and together, they form a sentence that nods to this book's title and also serves as a message for what we graphic designers do most: wrangle letters and images into engaging compositions."

UnderConsideration website, design and programing by Armin Vit.

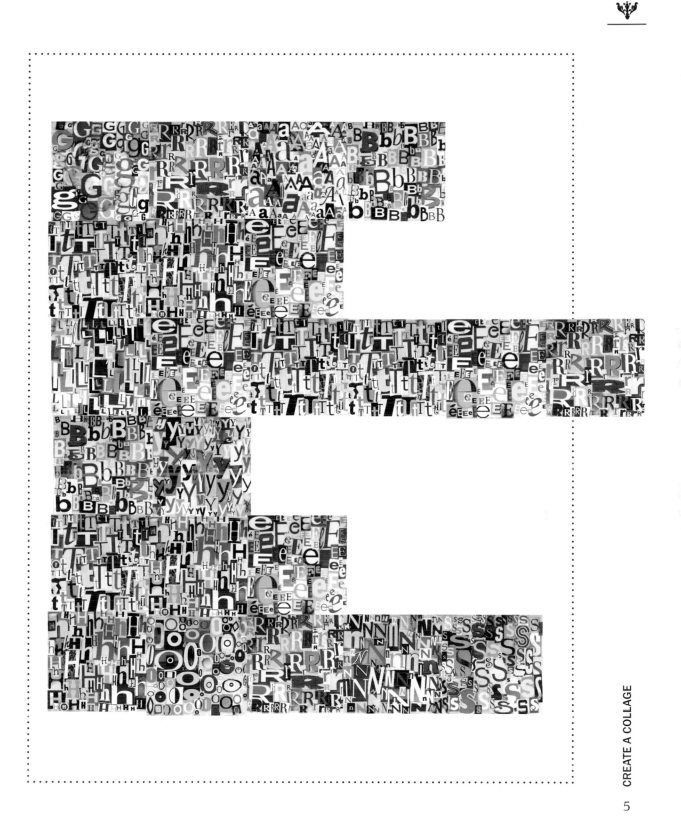

CREATE A COMIC STRIP

RAGNAR FREYR

www.ragnarfreyr.com

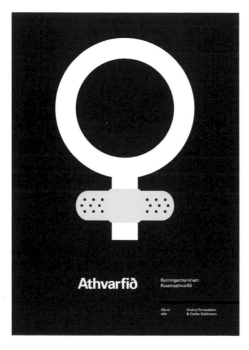

"Athrartid," a poster by Ragnar Freyr.

Ragnar Freyr is a twenty-eight-year-old graphic designer from Iceland. He currently resides in Reykjavik with his wife and the million-dollar pug. When Ragnar was a small boy, he dreamt of being many things when he would eventually grow up. He wanted to be an archeologist, a chemist, a priest, a horse breeder, singer, dancer, teenage mutant ninja turtle, journalist, professional athlete and much more. Of all those very cool things, he unexpectedly chose to be a graphic designer.

"After being assigned the creative task of making a comic strip, I quickly became anxious because I am one of those designers who admittedly lacks basic drawing skills. After reading Scott McCloud's *Understanding Comics*, I realized that a comic strip is not entirely about how well you draw it but about the idea it conveys. My idea was to show how absolutely thrilling and adventurous my average day is in front of the computer screen."

Average Day

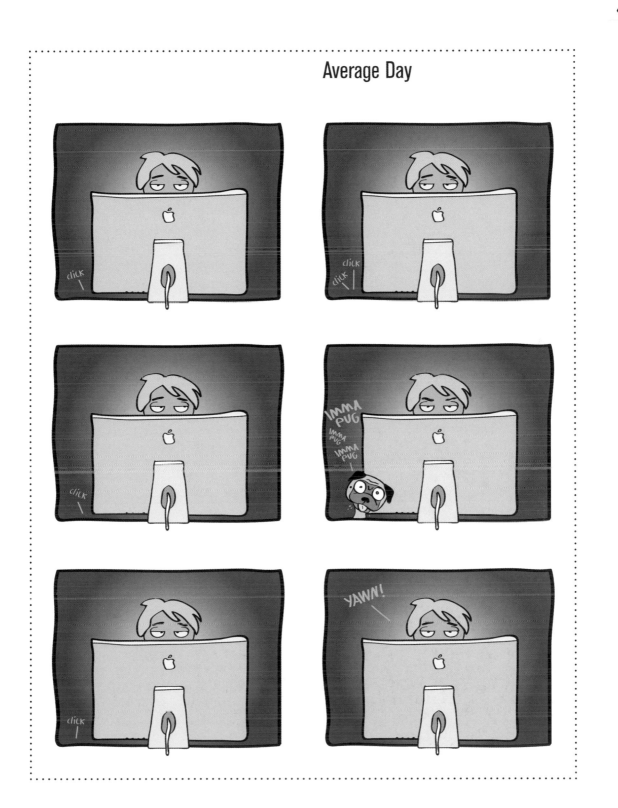

DIGITALLY MANIPULATE A PHOTOGRAPH

CARIN GOLDBERG

························► www.caringoldberg.com

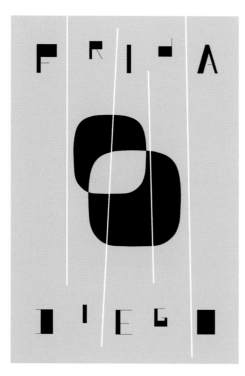

"Frida and Diego," a poster by Carin Goldberg.

Carin Goldberg is principal of the New York-based Carin Goldberg Design, where she has designed a zillion book jackets, dozens of record covers, a handful of posters, a bunch of magazines, four or five books and most recently, several editorial illustrations. Before founding her own shop in 1982, Goldberg worked as a staff designer at CBS Television, CBS Records and Atlantic Records. Her work is included in the permanent collection of the Cooper-Hewitt, National Design Museum. She was president of the New York Chapter of AIGA for two years and has taught at New York's School of Visual Arts since 1983.

" Although I am, in fact, technologically challenged (as assumed by the assigner of this project), I do know how to erase pretty well in Photoshop. This limited skill inspired me to photograph the classic Pink Pearl Eraser to create series of free-form, eraser-inspired riffs. Prudence Dudan worked with me on the project. "

DESIGN A TYPEFACE

CHRISTOPHER SIMMONS AND TIM BELONAX

············▶ MINE™ www.minesf.com

"This is our portfolio™," assorted ideas,
sketches and inspirations by MINE™.

Christopher Simmons is a designer, author, educator and design advocate. He teaches graphic design at the California College of the Arts, is the author of three books and writes the regular column "My First Time" for *STEP* magazine. Tim Belonax is a designer, thinker and provocateur. He's a graduate of the Rhode Island School of Design (RISD) and a former Chronicle Books fellow and an active member of Project M. Tim previously worked for top advertising and packaging design firms in San Francisco and Beverly Hills. MINE™ designs identities, books, consumer products, packaging, and print and interactive collateral for scientific visionaries, educational reformists, best-selling authors, museums, entrepreneurs, telecommunications giants and Hollywood producers.

<div style="vertical-text">CREATIVE GRAB BAG</div>

"A typeface is a collection of simple letters and symbols that can be organized to express complex thoughts. Our view is that language today—particularly the lexicon of design and branding—is actually becoming less granular. In design, terminology is being artificially created (and in many cases commercialized) in a superficial attempt to validate the value of creative services. Our typeface, "Synergy Grotesque," explores this codification by offering users a set of words (not letters) as the basis for expression. Like magnetic poetry or Mad Libs, words (all of which were farmed from popular 'brand dictionaries') can be arranged to support or subvert their intended meaning. The typeface is available as a free download from our web site above."

build an authentic brand experience by leveraging virtual language © ® ™

40 pt. synergy grotesque bold

we offer strategic social synergy.

30 pt. synergy grotesque bold

the essence of our core promise is a generic future.

20 pt. synergy grotesque bold

synergy grotesque is a new typeface based on new ideas. traditional typefaces offer a stylish selection of letters, numerals and symbols which can be combined to create an infinite number of words (and therefore an infinite number of thoughts). the release of synergy grotesque ushers in the 2.0 era of type design. culled from the best brand dictionaries available, synergy grotesque includes a limited set of words and concepts, carefully selected for their impactfulness™ and jargonosity.™ a typeface that dares to zag where others only zig, synergy grotesque is perfect for design firms, ad agencies, branding consultants and anyone who wants to be heard but not understood.

also included

not/has/you/i/be/will/are/our/an/a/won't/can't/was/is/which/that/or and/the/this/if/but/we/me

co- re- ing ed ly s

ligatures

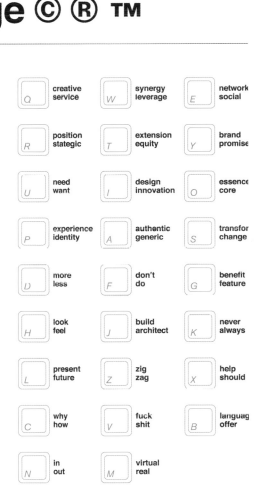

Q creative service	W synergy leverage	E network social
R position stategic	T extension equity	Y brand promise
U need want	I design innovation	O essence core
P experience identity	A authentic generic	S transfor change
D more less	F don't do	G benefit feature
H look feel	J build architect	K never always
L present future	Z zig zag	X help should
C why how	V fuck shit	B language offer
N in out	M virtual real	

"39 Things on Broadway," a drawing by Peter Arkle.

Peter Arkle grew up in Scotland and moved to London when he was nineteen to go to art school. He moved to New York in 1995 and has lived there ever since. He works as a freelance illustrator for a wide range of books, magazines, newspapers, advertising and design clients. His regular clients include *The New York Times*, *Business-Week*, *New York Magazine*, Kennedys (the law firm based in London) and Bumble and bumble (a hair salon and hair product maker in New York). He sometimes manages to publish his own newspaper, *Peter Arkle News*, which he fills with detailed drawings and stories of everyday life. He has had the same cell phone for five years.

"It took me longer to think up an imaginary brand than it did to design the logo. I settled on Nice!, a fictitious manufacturer of basic, but high quality, cell phones. They only make and receive calls and texts, have simple graphics and are light and small. No gimmicks. Phones for grown-ups who aren't interested in lining up to get the latest model from Apple or whomever. They are made of materials that look good as they age. They can be repaired and updated. They are meant to be kept for a long time. People are proud of how long they have had the same phone. … They are therefore much more eco-friendly than your average kept-not-even-for-a-year phone. They are designed to work anywhere on earth without having to spend hours dealing with annoying sales people in a busy store. "Nice phone!" exclaim people when they see your phone. "Nice phone!" You think every time you use it. … I considered using [Adobe] Illustrator to make the lines of the logo all high tech and smooth, but then decided that (a) I didn't know how to, and (b) the handmade look was a better fit for this friendly and human imaginary company."

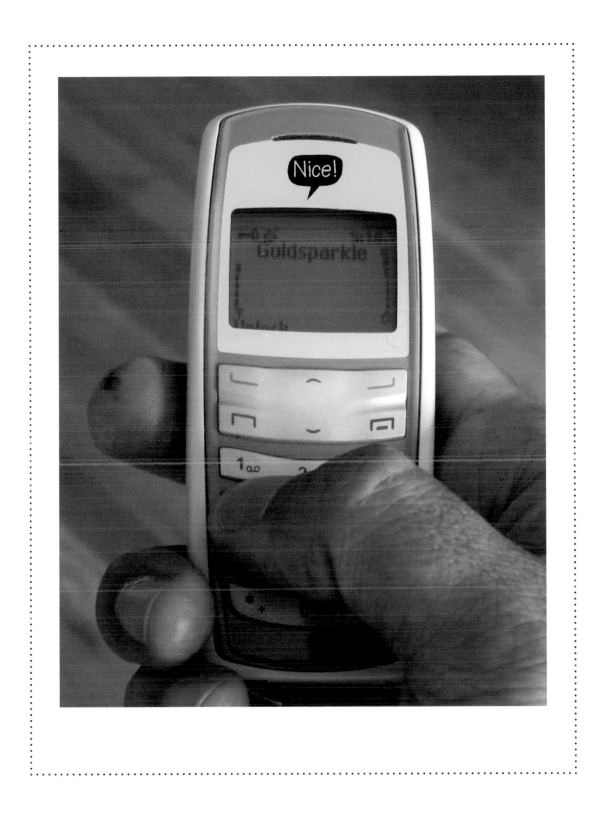

RICH LYONS

www.breakmould.com

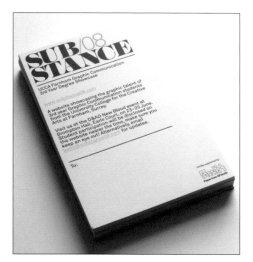

"SUBSTANCE/08 Cards" by Rich Lyons.

Rich Lyons is a graphic designer living and working in London at SEA Design. He completed placements at SEA and BB/Saunders prior to graduating with a BA with honors in graphic communication. He was also involved in the designing and curating of the Open Journeys exhibition at Beyond The Valley, London. He pitched the 50 Years of Helvetica project at the Design Museum, London. He also collaborated with Toby Evans to promote selected students' work, and as a result, designed a web site and promotional cards for a showcase titled SUBSTANCE/08. He believes being a quarter Swiss has defined his love for the modernist styles of the '60s and '70s.

Everybody's Welcome at Mrs. Mills' Party is the name of a 12" LP from 1963, bought as a result of me challenging my friend to buy me "something good" for 50 pence from a car boot sale. At a time in my life where I'm constantly overwhelmed by superb design work, the record in question has a sleeve design so bad, it's amazing. From the number of inconsistent typefaces and sizes across the whole cover to the badly cut-out (and blurry) photo of Mrs. Mills, the design oozes with hilarious defects that are so refreshingly funny, I can't help but love it. I found it the perfect inspiration for my T-shirt design … I instinctively found it difficult to step around the obvious boundary of designing for actual application on fabric, having previously screen printed shirts of my own. The limits of screen printing can sometimes produce some great overlaying results, so I have tried to simulate that effect. I think every so often it's important to take a light-hearted approach to design in the midst of applying so many rules and systems to functional design, so here we have it—something stylish and "designed," but ultimately based on a fun concept.

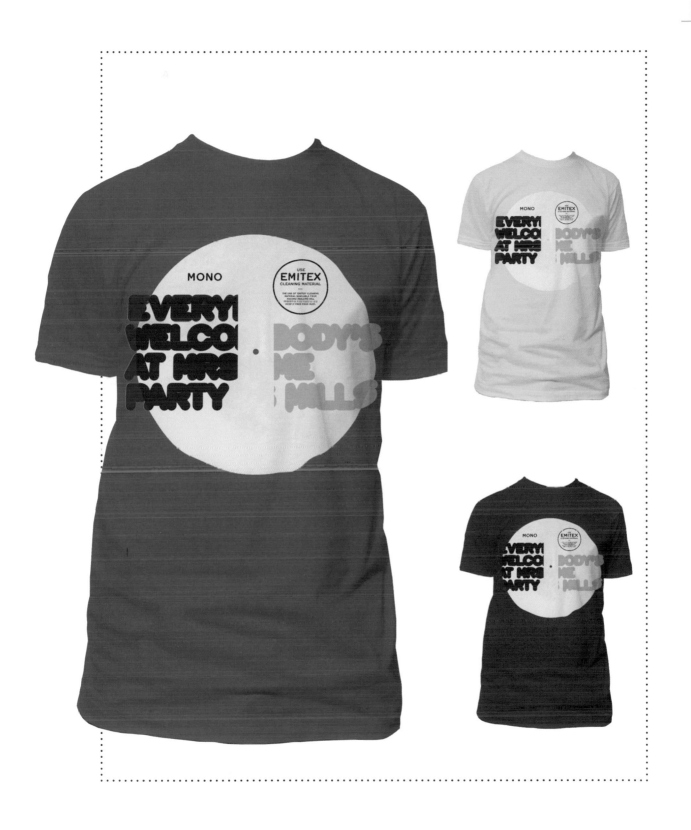

15

RYAN COX

www.ryancoxusa.com

Ryan Cox grew up in Kansas City, Missouri. Now he lives in New York City and works as an illustrator and graphic artist. Since 2002, he has provided illustration and character design for a wide variety of print, motion, apparel and web projects commissioned by clients across the globe. His current favorite things include drawing, swimming, Redd Kross and summertime.

"Back to School," an illustration by Ryan Cox.

❝This project actually turned out to be pretty tough. Not because I'm not a photographer (by any stretch of the imagination), but because hardly anyone on the streets of New York City would let me take their picture. The masks I created actually served as my crutch. I figured strangers would be more likely to participate if there was a cool prop involved. I was wrong. In terms of working on a project outside of my normal realm of work, I found that challenging too. Photography and illustration are two completely different animals (duh) even though, at the end of the day, both are means of making an image. I think these photos turned out kind of funny, although it's pretty obvious I didn't know what I was doing. But I guess that was the point.❞

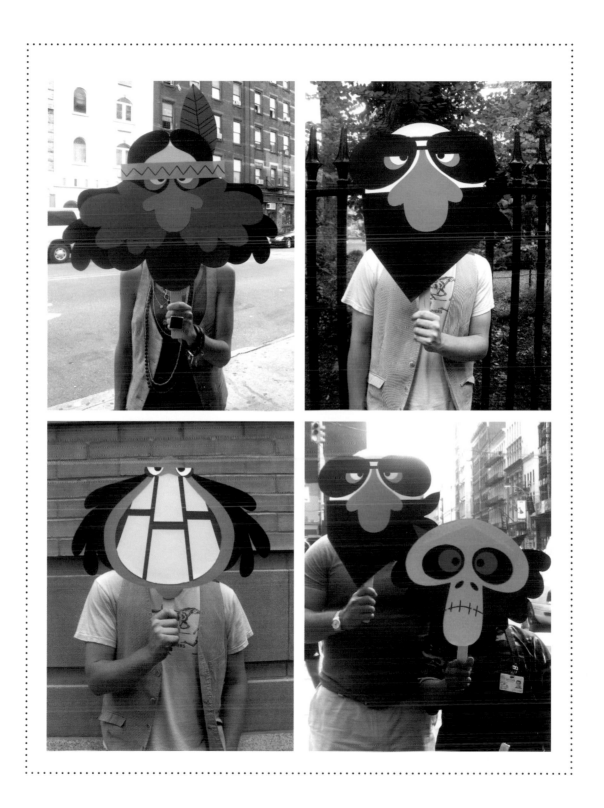

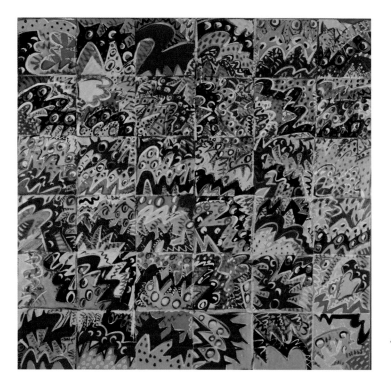

Born in New York City in 1950 and educated at the School of the Art Institute of Chicago, Rusty Brockmann has been on the faculty of the Chase Collegiate School in Connecticut for twenty-nine years. He is the art department chairperson and teaches studio and art history courses. Primarily a painter, his work incorporates an array of materials and sensibilities.

"Zhenna," acrylic and mixed-media painting by Rusty Brockmann.

66 No matter what you do, I don't think you can ever leave yourself, visually. What you do, what you make, these are wound always together. This piece engages memories and certain emotional reference points. When I step back, I really go back and reconsider what held me fast to that time. The whole act of creating is somehow involved in time—the time it takes to do it, the time to accumulate the connections, the referenced time—all these come together. 99

CREATIVE GRAB BAG

18

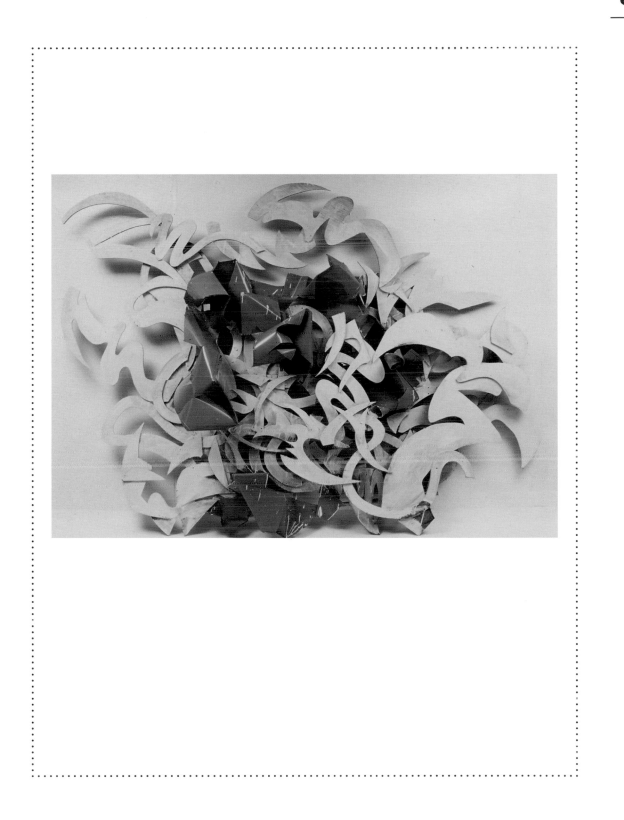

CREATE A COMIC STRIP

RYAN KATRINA AND MIKE MCQUADE

······▶ NATIONAL RECORD HOLDERS
www.nationalrecordholders.com

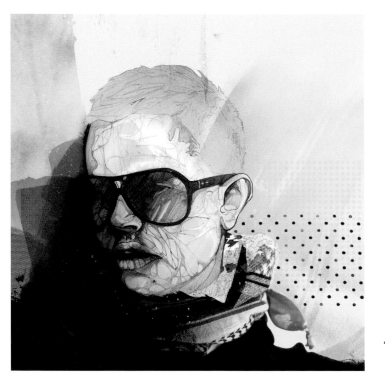

National Record Holders is the collected work of creative cohorts Ryan Katrina and Mike McQuade. Although known more for their solo efforts under the monikers Neuarmy (Ryan) and Juxtavision (Mike), these two have worked collaboratively for *Overspray* magazine, Comcast Interactive Media and *Maxim* magazine, as well as projects like Good Wood (custom skate deck show, Detroit/Brooklyn) and Newborn Art Show at the XChange loft, Soho.

"Illustrated Portrait," hand-illustrated portrait in pencil of Ryan Katrina by Mike McQuade.

" National Record Holders was tasked with creating a comic strip. Our approach to the project was not the standard horizontal strip with humorous dialogue, but more of a simple introduction to a cast of gnarly characters: Bucktown Bear, Jigga Bit, Task Master, Little Big Jawn and Stegahawk. Each personality is loosely based on certain people that have come in and out of our lives at one point or another. They are all record holders in their own right. And they are all absolute winners. "

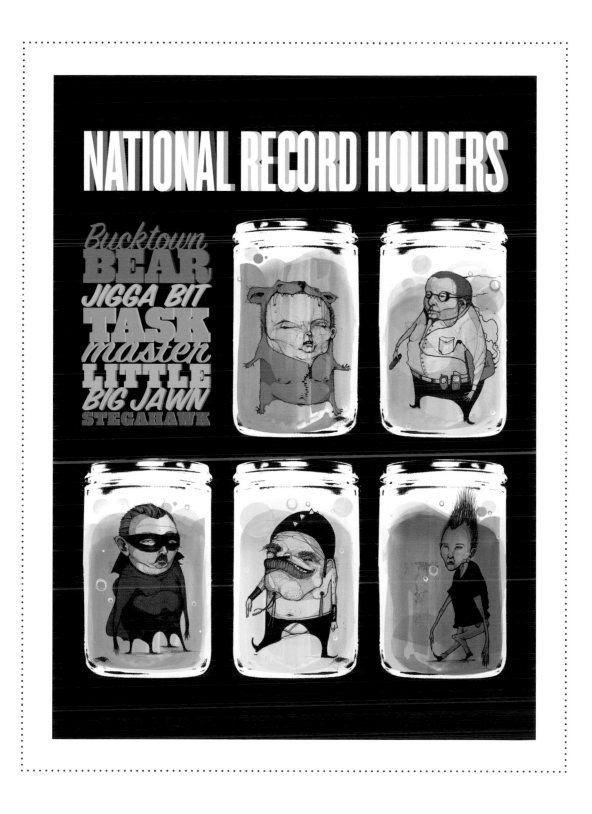

CREATE A SCULPTURE

JUDY LEE AND SHAWN LIU

WE SHALL SHORTLY
www.weshallshortly.com

Judy Lee and Shawn Liu started working together in 2006. Judy is a painter and a bookmaker; Shawn doodles and fancies himself to be a photographer. She started her own line of artist journals called Five and a Half in 2006. He is the cofounder of Iridesco LLC and has happily worked there since 2003. Together, Judy and Shawn have a design studio that they've named We Shall Shortly. When they are not working, Judy likes to indulge in watching *The Hills* while eating a bowl of chocolate chip cookie dough ice cream, while Shawn surfs on YouTube for clips of *So You Think You Can Dance* (dessert is optional). They share an unexplainable weakness for Domino's Pizza.

"We Shall Shortly Café" by Judy Lee and Shawn Liu.

> We like the idea of creating new things out of discarded objects. We also like cafés: Shawn likes coffee, Judy likes cakes. It's never occurred to us that we could combine the two, so with this sculpture we created a table setting of our imaginary café using discarded paper. It still surprises us to see how dramatically waste paper can change form. Every time we walk by the cup of paper coffee, we want to pick it up and take a sip.

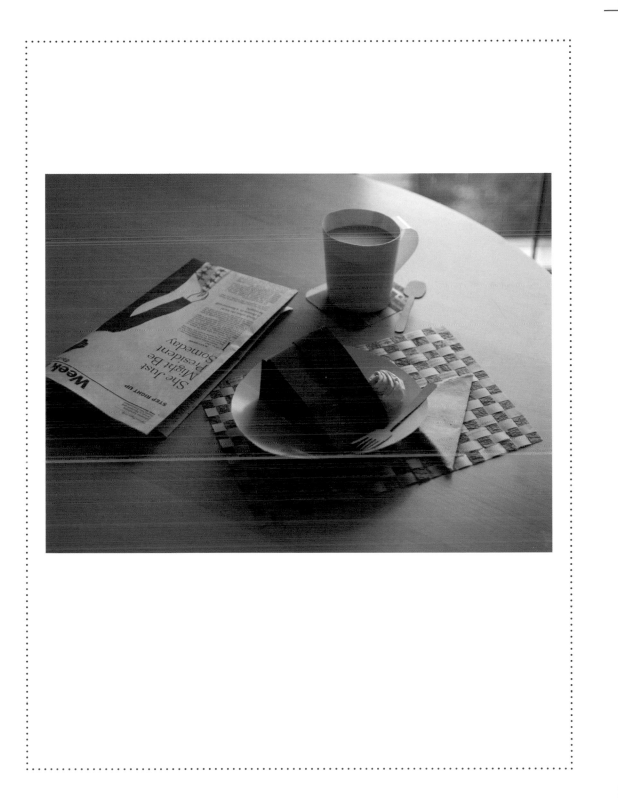

DESIGN A BUILDING

BEN BARRY

www.designforun.com

"Buy a Meter" by Ben Barry.

Ben is a young designer who currently lives in Austin, Texas. During high school, he interned for a local architecture firm before going to the University of North Texas to study graphic design. He organized his school's design club and designed his university's literature journal. He has also won numerous awards and had work featured in various industry publications. In June 2007, he participated in Project M, an intense experimental design project focused on social issues and run by John Bielenberg. Currently, he spends his days working at The Decoder Ring in Austin making lots of screen-printed show posters.

CREATIVE GRAB BAG

24

" As a designer, I need to have a problem to solve for my creativity to manifest itself. Having only the prompt to "design a building" was a little bit too open ended for me, so I found myself having to construct boundaries for myself. In June 2007, when I was participating in Project M, I was exposed to the work of the truly inspirational Rural Studio architecture students from Auburn University. One of the many projects we discussed was the potential of opening a boutique hotel/café/bookshop. In the past year, that idea has become more and more of a reality as the current Mayor of Greensboro is willing to sell us an existing burned-out building on Main Street for $1, the stipulation being that we must redevelop it. The idea would be to keep the existing historic shell but to build a new modern glass building inside of it. I especially enjoy the idea of mixing old and new styles into one unique structure. Perhaps at some point in the future, this will actually become a reality. My only hope is that I will get to collaborate with some of the much more talented Rural Studio students. "

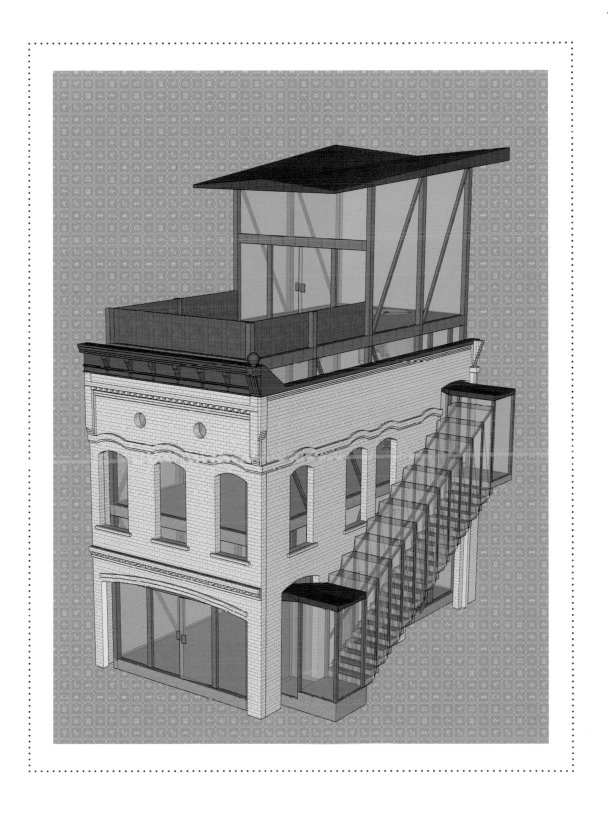

MAKE A WRAPPING PAPER PATTERN

CHRISTOPHER BARRETT, EDWARD HEAL AND LUKE TAYLOR

US (DESIGN STUDIO)
www.usdesignstudio.co.uk

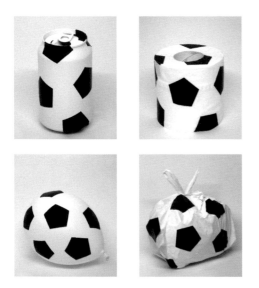

"Art of Football," posters by us (design studio) for Nike and YCN.

us is a multidisciplinary graphic design studio working within brand identity and development, art direction, motion, advertising and printed literature. They believe that design should stem from good ideas no matter how big or small. As a studio, they create work that excites, inspires and, most importantly, meets the needs of the client.

"We started to think about how the concept of wrapping paper is flawed: As soon as it's served its purpose, it is disposed of. As people will always use wrapping paper, we came up with the idea of taking the standard recycle logos and using them to create an aesthetic pattern. By doing this, we hope to promote recycling and the use of paper from sustainable sources."

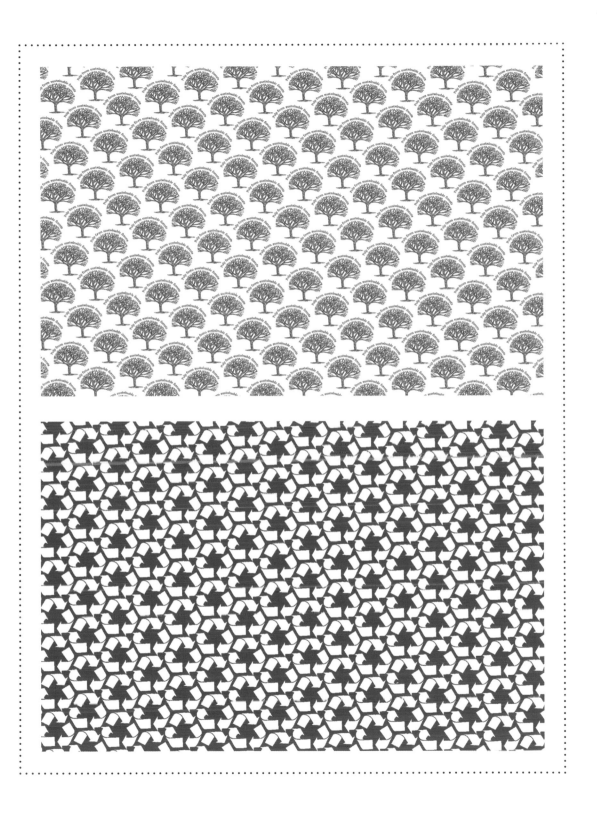

CREATE A COMIC STRIP

JOSHUA PYLES

www.joshuapyles.com

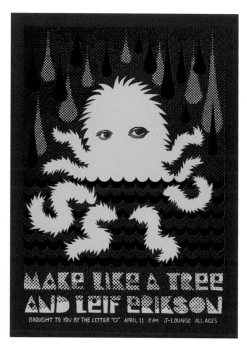

"Make Like A Tree and Leif Erikson," a gig
poster by Joshua Pyles.

Joshua Pyles is an illustrator, designer, singer, storyteller and humorist who currently haunts the Midwest. He was born and raised in St. Louis, Missouri, and is a graduate of the Savannah College of Art and Design. Joshua first gained infamy for his "Faux Tours," comedic and inaccurate bootleg tours of local art museums, and then for his rumored relationship with actress/musician Zooey Deschanel (which she denies ever happened). These days, Joshua spends his time designing gig posters, T-shirts, editorial illustrations and whatever else seems like the most fun.

" When I started out as an artist, my focus was really on comics, but I have found that I rarely do anything sequential anymore. It was interesting to try to get into that train of thought again. I believe that comic strips are one of the hardest things to do well because they are so concise. When you look at my comic strip, you have to realize that it's not about what is there, but what isn't there. It's like jazz or a broadcast of *Showgirls* on VH1. I originally had a lot of clever dialogue written for the honey bear, but after looking at him for a while, I just couldn't imagine him saying any of those things I had written. It didn't fit. He is too naive. "

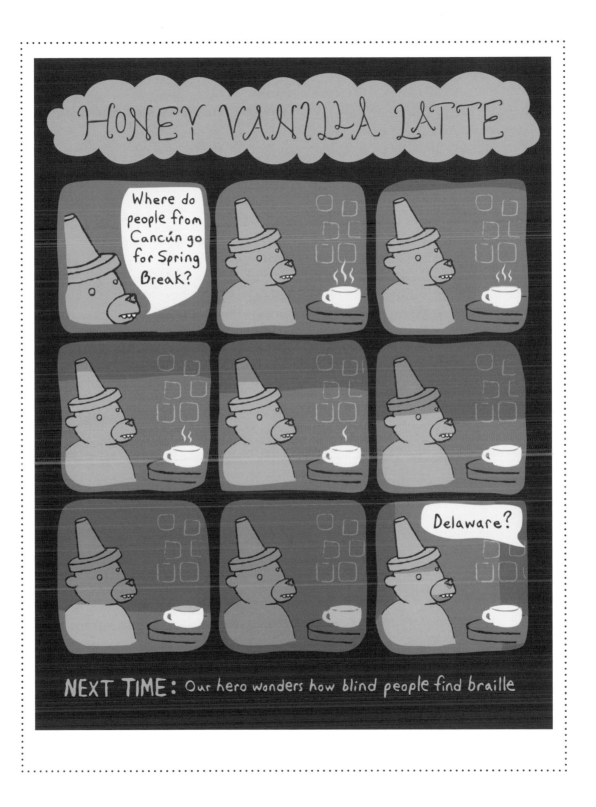

CREATE HAND-DRAWN TYPE

JASON PUCKETT

http://everydaypuck.blogspot.com

As an art director at MasonBaronet, Jason handles projects from concept through production for clients in the law, technology and financial industries. A graduate of the prestigious Portfolio Center in Atlanta, Jason has an extensive background in marketing, retail and corporate work. His training at Portfolio Center has helped him develop both sides of his brain: his design process and an awareness of how brands are created. His work with this organization helped him earn a marketing internship with PDI/DreamWorks during production on the Academy Award–winning film *Shrek*. At home, Jason has an extensive collection of DVDs and is a confirmed film buff. He and his wife have a two-year-old son, Ian.

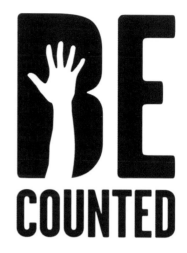

"Be Counted," a logo for Texas Trial Lawyers Association Political Action Committee, by Jason Puckett.

> My personal experience with handwritten typography is fairly limited. So I was both elated and on edge about my creative task. What I love about hand-drawn type is its free-form, unpredictable nature. Kerning, proportion and baselines are open for experimentation and letterforms can come from anywhere. You can find typographic inspiration on your desk, in nature or in your refrigerator. My challenge is just letting it be. Don't try to clean it up or pencil it out or have Suitcase opened on your laptop in front of you while you're drawing. Just let the type draw itself. That's what I wanted to explore: how ordinary type can become extraordinary when handwritten. It doesn't have to fall into a specific classification (serif, gothic, script); it can be a pair of scissors.

SCOTT BURNETT

AAD www.studioaad.com

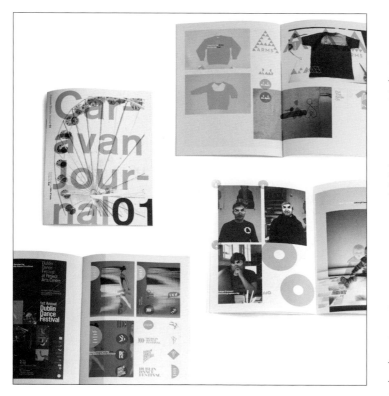

"Caravan Journal 01," an A6 publication by Scott Burnett for Caravan Creative Studios.

Scott Burnett is a man who won't make up his mind. After studying graphic design at Gray's School of Art in Aberdeen, United Kingdom, he moved into the field of photography. After three years working as an assistant for photographers in Glasgow and London, he moved to Dublin and back into graphic design. It wasn't long after this that he decided to take up DJ-ing by starting his own party night. He started a clothing label called Angry with his business partner Johnny. In 2005, they decided to retire from the fashion game and move back into graphic design with their studio and consultancy Aad (Art & Design). In 2009 Aad will launch a new clothing label, Arms. Burnett's academic thesis was titled "Non-Specialised Design: The Practicalities and Possibilities."

CREATIVE GRAB BAG

" Any excuse to explore my creativity is fine by me. I love working as a graphic designer. I love the problem solving, the technical aspects and the physical craft of it. Most of all though, I love the creativity of it—having ideas and bringing them to life. Not all my ideas fit neatly onto a poster, into a book or on a T-shirt though. Sometimes, I just have to bust down the professional boundaries and throw some shapes in a different area. I loved the idea for this book, a random creative task pulled from a bag—an excuse to do something different. As I said, any excuse to explore my creativity is fine by me. "

DESIGN A PIECE OF FURNITURE

EDVARD SCOTT

www.edvardscott.com

"Untitled 01" by Edvard Scott.

Edvard Scott is a self-taught illustrator and graphic designer based in Stockholm. Over the past years, Scott's work has attracted the attention of big-name companies—both in Sweden and internationally. Working with animation, interactive media and print, Scott's clients include Nokia, L'Oréal, MINI Cooper, *Shift*, Graniph and START MOBILE, and his work has also been published in books and magazines such as *+81*, *Grafik*, *Arkitip*, *Computer Arts*, *NeoGeo* and *Illusive 2*. Scott's work has been exhibited in solo and group shows in Japan, the United Kingdom and the Netherlands.

> It's obviously great fun to explore your creativity. But I can think of nothing more difficult than to describe what it means, how to explain the result and how it works. Applying one set of thoughts and values on another medium is complicated—but nonetheless very interesting. Being a graphic designer and illustrator, designing something three-dimensional is rather difficult since I've been taught to think in two dimensions. I got asked to design a piece of furniture, and I chose to design a series of bookshelves. It was the first thing that came to my mind, and I'm rather pleased with the result. I'm not sure what the process has taught me, but I feel that it's always, always good to try new things and to widen your perspective (even though a new dimension might be too much for me).

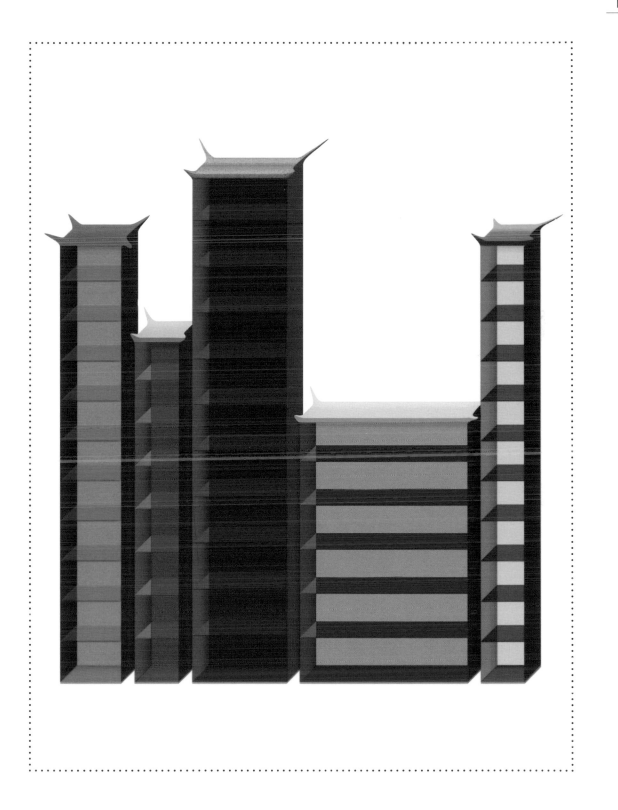

DESIGN A PIECE OF FURNITURE

35

CHRIS GLASS

www.chrisglass.com

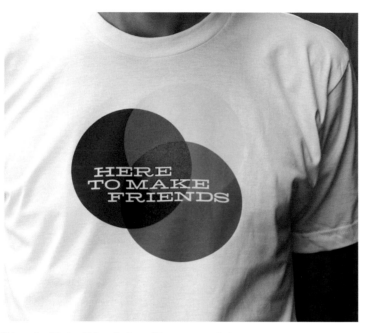

"Here to Make Friends," a silkscreen print on T-shirt by Chris Glass.

Chris Glass grew up in southwestern Ohio surrounded by colored pencils, drawing books, sets of LEGO, fields of corn and a very creative and supportive family. While attending The Ohio State University for a degree in visual communication, he found himself straddling a transition in design education. Darkrooms were replaced by Photoshop, and laser printers took the place of transfer type. He enjoys mixing human elements into traditionally rigid constructs of digital production in his products at Wire & Twine—a company he founded alongside friends in 2006. Chris is almost never without a camera, capturing photographs daily that he erratically posts in an online journal so he can rely on Google instead of his memory.

" The task of designing a book cover, with little or no constraints, was particularly daunting for me. (Back when I attended Ohio State, the design degree was a bachelor of science, not arts.) The freedom employed in this task did not jive with a process-oriented approach. I need constraints! It is this struggle that inspired the ultimate result. I started with a favorite photo of leaves from last autumn. All the colors of the season were represented on a single tree that day. It appealed to the designer in me that hopes to understand and find ways to organize information. A fictitious guide to describing color seemed appropriate and lent the image some much-needed context. Actually, printing the cover and placing it in a physical space grounded the book into something tangible and unflat—something filled with life. The worn edges suggest the paperback has been used and referenced for many years—cherished and shared, much like the collective grab bag contributions that fill this book. "

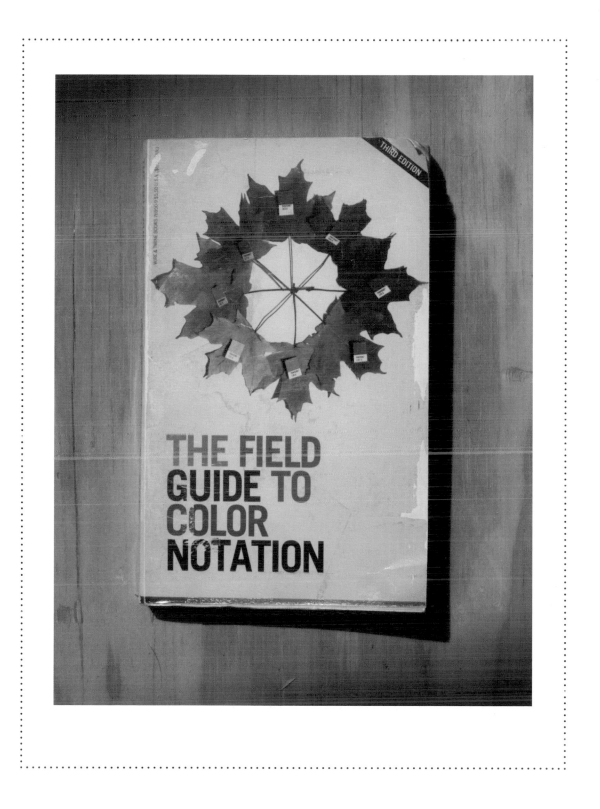

ELLEN LUPTON

www.designwritingresearch.org

An illustration for the *New York Times* Book Review by Ellen Lupton, acrylic paint and digital.

Ellen Lupton is a writer, designer, curator and educator. She is director of the graphic design MFA program at Maryland Institute College of Art in Baltimore, and she is curator of contemporary design at Cooper-Hewitt, National Design Museum. She is the author of numerous books on design, including *Thinking With Type* (2004), *D.I.Y.: Design It Yourself* (2006) and *Graphic Design: The New Basics* (2008). She is working with her sister Julia on a new book titled *The Design Files: Delight and Dysfunction in Everyday Life* (2009). She received the AIGA Gold Medal for lifetime achievement in 2007.

"

When I was a child, I recall trying to fix certain mundane images in my mind, vowing to hold onto them forever. One of them was an image of sheer curtains hanging in my Aunt Verna's house in Cape May, New Jersey. I decided that I wanted to remember this image, not because it was especially important or beautiful, but simply because I had chosen it for preservation. It would be like a snapshot in a picture album that is undistinguished by anything but its good luck to have survived. Aunt Verna passed away soon after I decided to remember her curtains. Hers was the only funeral I attended as a child. This is how I remember the room. "

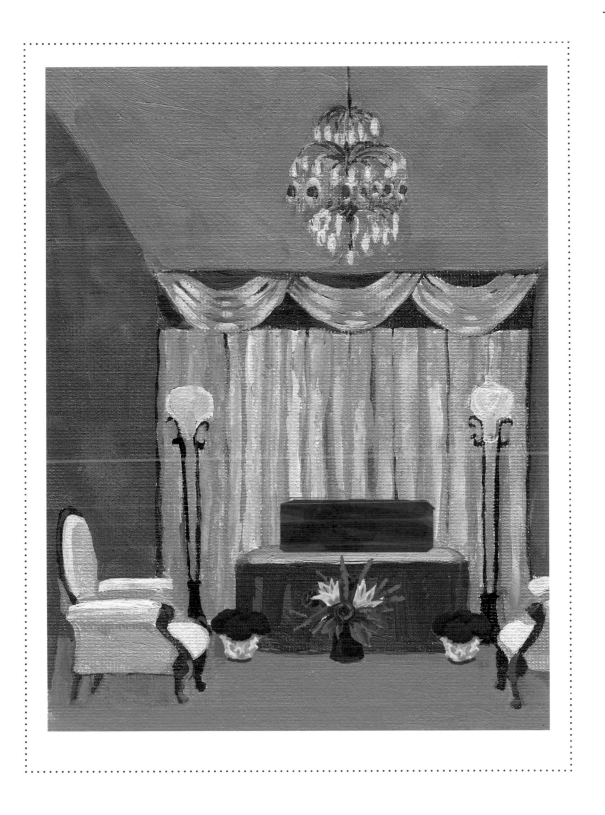

DESIGN A PAIR OF SHOES

MASSIMILIANO PANZIRONI

www.dolceQ.com

Massimiliano is part of DolceQ along with Sonia Di Rubbo. The creative duo hails from Rome and creates a sexy, lovely world where butterflies, hearts, stars and women live together in a minimal, erotic futuristic style. The pair work across a huge range of projects, from music videos, art shows and editorial projects to customized iPod covers, sketchels (custom art satchels) and designer toys. During the international design contest sponsored by The Coca-Cola Company and Play Imaginative in 2007, Massimiliano Panzironi's custom designed "Passione" was selected as one of only fifteen winning designs out of four thousand combined entries from seventeen countries.

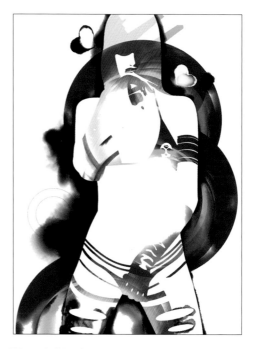

"Female" by Massimiliano Panzironi.

"Taking part in this project was really fun and challenging. I had the chance to use a different means to experiment with my creativity, and I could see the effect of my work on a pair of sneakers, which was really amazing. I believe that exploring creativity is a fundamental step in the artistic development of each artist, and it's even more important when playing a role in projects like this."

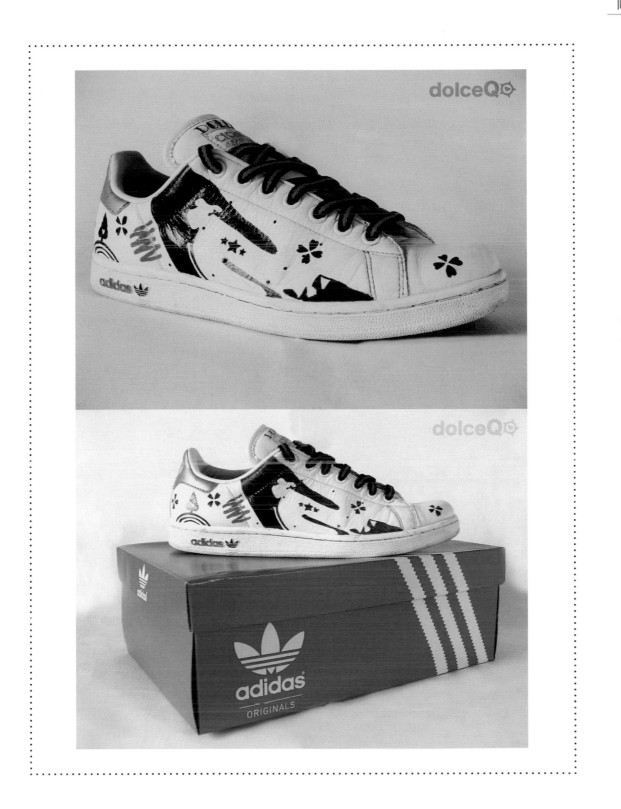

DESIGN A CHARACTER

J. BYRNES

ADAPT-STUDIO, INC.
www.adapt-studio.com

"Gracías," mixed media on wood by J. Byrnes.

Adapt-Studio, Inc., directed by J. Byrnes, believes that it all comes down to communication. They are a creative studio whose capabilities include, but are not limited to print, name and identity development, packaging, web site design and illustration. Working as a team allows them to accomplish much more than they each could alone. It is important for them to have a complete understanding of the client's niche in the marketplace.

66 The concept of the project is great. I try to incorporate the idea of trying something new in some sense into all of my work as well as my life. Many times, I feel a sense of discomfort when trying new things. I have decided that this is a good thing. It allows me to push myself and trust the process. Often, I put a lot of weight in the final product, which is important, but the reason I make the art is because I love it. I am challenged by it. The *Creative Grab Bag* experience gave me both the opportunity to try something I may not have otherwise tried and it allowed me to share my work with others. 99

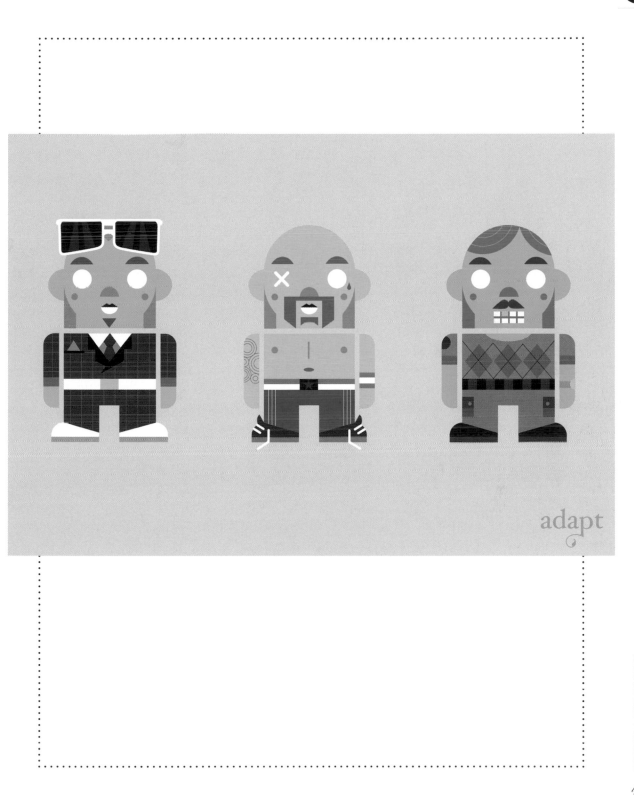

CREATE AN INFORMATIONAL GRAPHIC

JEREMYVILLE

www.jeremyville.com

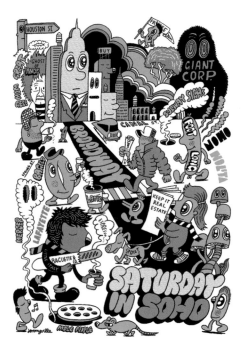

"Saturday in Soho," a three-color screen-print by Jeremyville.

Jeremyville is an artist, product designer, animator and human. He wrote and produced the first book in the world on designer toys called Vinyl Will Kill, published by IdN. He has interviewed Fafi, Sarah from Colette, Baseman, Biskup, Pete Fowler, Jason Siu, Kinsey and Kozik. He was in a group show at Colette in 2007 alongside KAWS, Fafi, Futura, Mike Mills and Takashi Murakami. He has initiated the "sketchel" project, creating custom art satchels with artists like Beck, Genevieve Gauckler, Gary Baseman, and around five hundred other artists. Jeremyville splits his time between studios in Sydney, Australia, and New York City. He collects rare T-shirts, sneakers, toys and denim.

> "For this project, I wanted to take an abstract concept, such as "hopes and aspirations," and assign very real percentages to the various characters outside Penn Station in New York. These characters are representations of my various moods throughout the day, from futility to elation."

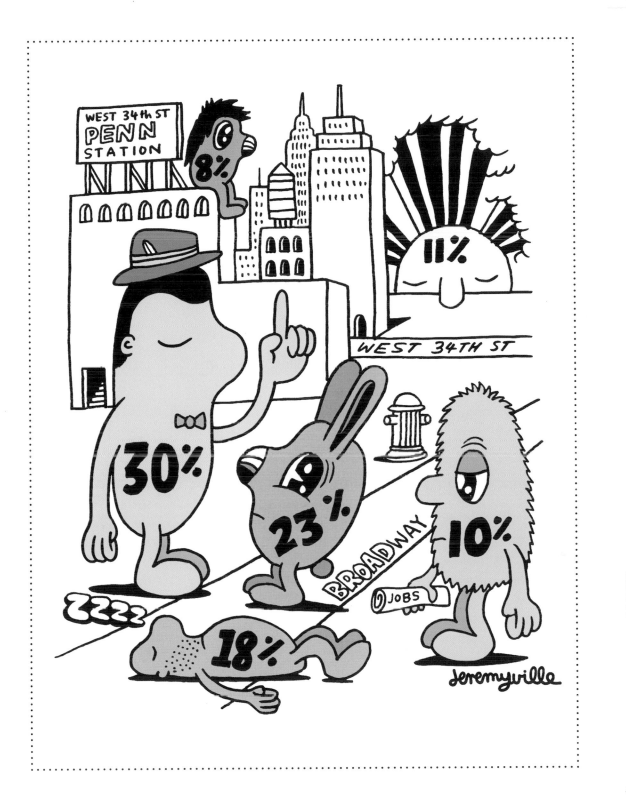

JOSIE MCCOY

www.josiemccoy.co.uk

"Jane Smith I," oil on canvas by Josie McCoy.

Josie McCoy paints portraits of characters from film and television. Her paintings represent an isolated moment and present a subject matter, which although fictional, is familiar within contemporary culture. She graduated with an MA in fine arts from Central Saint Martins College of Art and Design, London in 1999. Since then, she has exhibited widely, and her work has been featured in exhibitions in London, Santiago de Compostela, Milan, Paris and New York.

"My usual paintings are portraits of film and television characters. The source material is predominantly from a range of photographs taken from the television screen. I choose close-ups as they usually signify a highly emotional, poignant or significant moment in the film or television program. I'm interested in what we bring with us in terms of our own experiences and references when we look at something out of its usual context. My task for the *Creative Grab Bag* book was to take four photographs of people I didn't know. My first reaction was to take photographs of the television as I would for my normal work. Instead I chose to photograph strangers in the street during Fallas (a fiesta in Valencia, where I live) and in a restaurant and club in Santiago de Compostela where I had an exhibition at the same time I was doing the task. Participating in the *Creative Grab Bag* book enabled me to explore an area of creativity that I hadn't previously considered. It was an interesting experience, which expanded the way I look at the world."

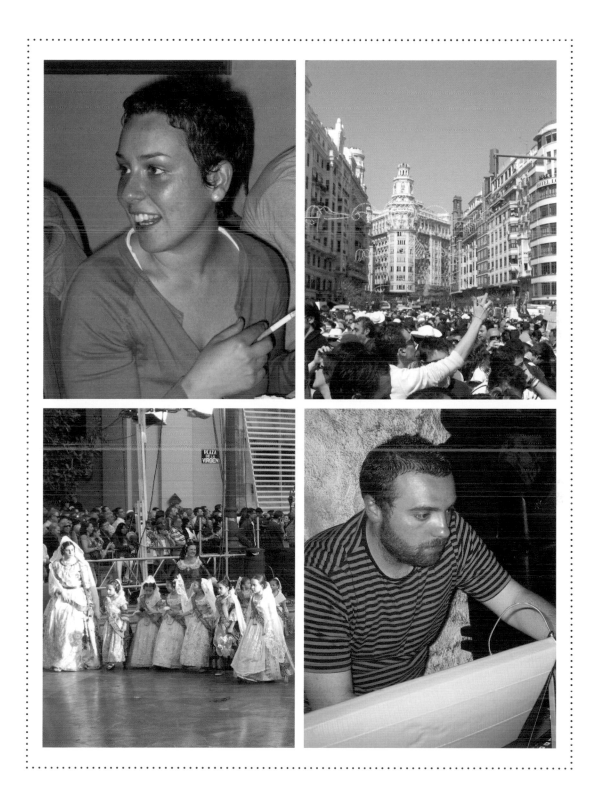

"Amateurs," an illustration by Justin White.

Justin White, also known as Jublin, is an illustrator currently living in Southern California. He enjoys the simple things in life, such as drawing, watching cartoons, eating hamburgers and playing Chinese checkers. One day, he hopes to work in animation, but for now he is striving to improve his skills in illustration and design.

" As an artist, I think working on new projects in unfamiliar territory can be one of the most challenging, yet refreshing, experiences. I don't even know what it means to be an artist, but I do know that once a challenge is set you can't back down. Just like Rocky in all of the *Rocky* movies. Or Bruce Willis in *Die Hard*. Artists are like Bruce Willis. They don't give up. In the end, I just felt this project would be a fun experience and it was. Again just like *Die Hard*. "

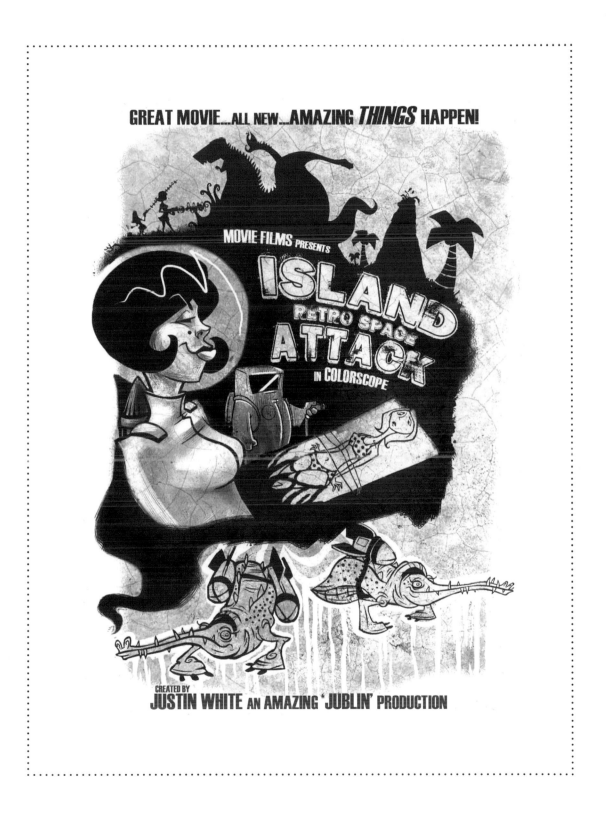

KATE BINGAMAN-BURT

www.obsessiveconsumption.com

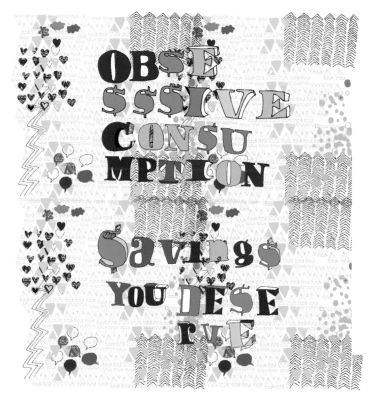

"Obsessive Consumption: Savings You Desire" by Kate Bingaman-Burt.

Kate Bingaman-Burt formed the website Obsessive Consumption when she decided to photograph all of her purchases and, in turn, create a brand out of the process to package and promote. She is currently hand-drawing all of her credit card statements until they are paid off, drawing something she purchases each day and continuing to make piles of work (zines, pillows, photographs, buttons and more drawings). She has had solo gallery shows in San Francisco and New York and has been featured in *The New York Times*, *Print Magazine*, *HOW* Magazine, *Hand Job* and *Netdiver*. She is an assistant professor of graphic design at Portland State University, after four years at Mississippi State University.

> I draw lots of type. Everyday. Lots of type. However, I have never made a full typeface. The experiment was a good one; it forced me to draw letters I normally don't (*q, z, x*). This project made me want to make type specimens for several different handmade typefaces. Right on.

ILLUSTRATE A MEMORY

LANRE LAWAL

www.tdjso.com

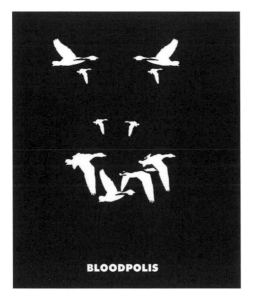

"Bloodpolis" by Lanre Lawal.

Lanre Lawal is a twenty-eight-year-old graphic designer, product designer and filmmaker based in Lagos, Nigeria. He cofounded a graphic design and animation firm called HomeMadeCookies in Lagos and was project director for four years for a team of up to six others. In 2005, Lanre left HomeMadeCookies to establish and direct The Design Jockey Sessions, which specializes in translating talent into products and seeks to use modern record-making paradigms to remix and produce visual, aural and tactile codes. In September 2005, he won The International Young Design Entrepreneur of the Year prize in London. In February 2006, Lanre was selected by the curators of Africa's biggest design event, The Design Indaba in South Africa, to showcase his work.

> This piece is based on the experience of taking bikes across the West African city of Lagos. A motorbike is called *okada* in Lagos. It operates on a functional level as a great stress reliever as it can always provide almost spiritual relief from chronic traffic jams; you can just weave your way out of it. And on the highways, it gives a sense of freedom. Almost a spiritual epiphany and that details the psychedelic nuance I expressed the memory with.

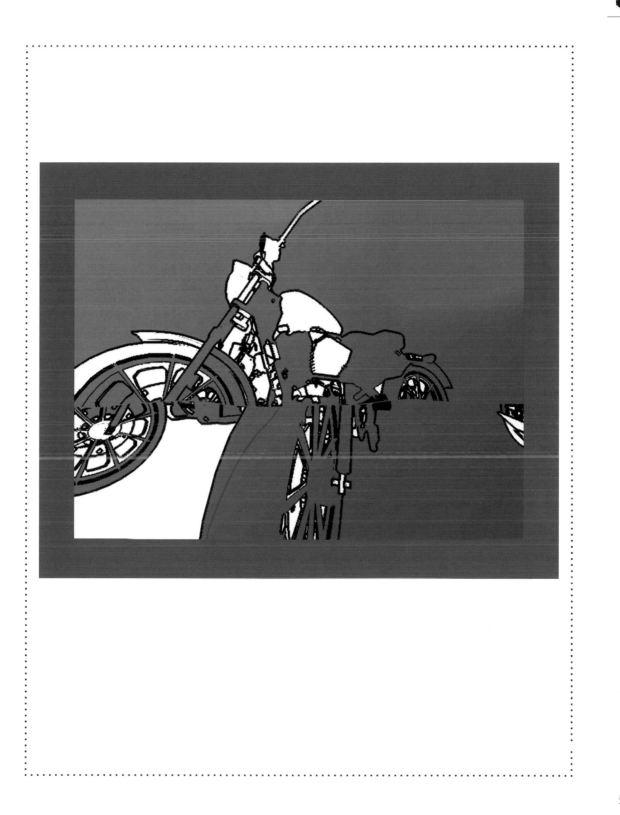

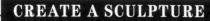

PAUL SAHRE

www.paulsahre.com

Graphic designer, illustrator, educator, lecturer, foosballer and author, Paul Sahre established his own design company in New York City in 1997. Consciously maintaining a small office, he has nevertheless established a large presence in American graphic design. The balance he strikes, whether between commercial and personal projects or in his own design process, is evident in the physical layout of his office—part design studio, part silkscreen lab—where he prints designs and posters for various off-off-Broadway theatres (some of which are in the permanent collection of the Cooper-Hewitt, National Design Museum). On the other side of the office, he designs book covers for authors such as Rick Moody, Chuck Klosterman, Ben Marcus and Victor Pelevin. Sahre is also a frequent contributor to *The New York Times* op-ed page.

Book cover for *Omon Ra* (hardcover) by Victor Pelevin, designed by Paul Sahre.

"I loved that car. I hated that car. I loved that car … For my sculpture I rearranged the parts of a '69 Dodge Dart model kit. I did this as a specific reference to a car I used to own. While living on the street outside my apartment in Brooklyn, it collected seventy-five parking tickets, it took two trips to the tow pound, it was broken into four times (twice with broken windows that were hard to replace) and sometimes it didn't start. Oh, and a tree fell on it. I finally gave up and gave the car to my older brother who lives upstate—and who has a driveway."

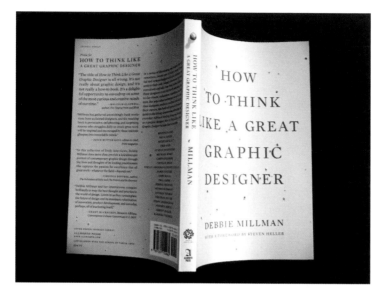

How To Think Like A Great Graphic Designer by Debbie Millman, cover designed by Rodrigo Corral, photographed by Michael Surtees.

Debbie Millman is a partner and president of the design division at Sterling Brands and teaches at the School of Visual Arts and the Fashion Institute of Technology in New York. She is also an author on the design blog Speak Up, a regular contributor to *Print* magazine and she hosts a weekly internet talk show on the VoiceAmerica Business network titled *Design Matters.* Her first book, *How To Think Like A Great Graphic Designer*, was published by Allworth Press in 2007, and her second, *The Essential Principles of Graphic Design*, was published by RotoVision in Summer 2008.

"This was a fun and challenging assignment from an impressive and ambitious young author. My mission was to design a typeface, which is about as far from my daily work as I can imagine, though, without the author knowing it, was also incredibly serendipitous, as I collect art featuring text and typography. I have been collecting this genre of art for over twenty years and developed this face as a homage to some of my favorite letters from the pieces hanging in my New York City apartment (hence the name of the face: APARTMENT). This includes manipulated letterforms inspired by the work of Donald Bachelor, Andrea Dezsö, Nam June Paik, Benjamin Franklin Perkins, Cary Leibowitz, Julian Schnabel, Maira Kalman, Tibor Kalman, Joseph Kosuth, Robert Barry, Lawrence Weiner, Robert Rauschenberg, Edwin Schlossberg and yours truly. "

Apartment

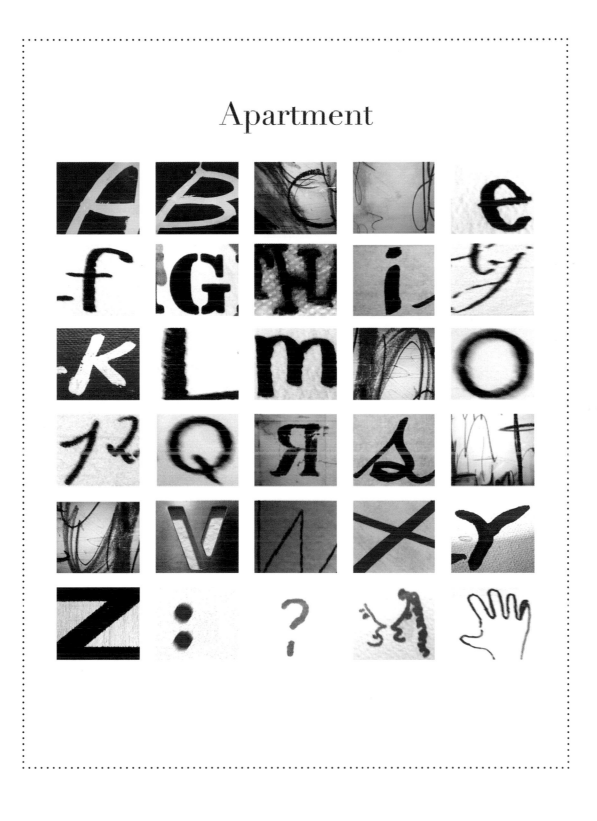

BEN FROST

www.benfrostisdead.com

"I Never Cared Much For Heavy Metal," acrylic and enamel on board by Ben Frost.

Ben Frost is a painter and illustrator who currently lives in Sydney, Australia. Best known for his collage style of post-pop painting, Frost collects and manipulates logos, comic book characters, corporate mascots and found surfaces, fusing them together into irreverent statements on the very environment they came from. Inspired by techniques and concepts from diverse areas, such as graffiti, photo-real painting and sign writing, his often large-scale works are complex mash-ups of popular culture that, he says, have been, "diced, sliced and warmed over the burning embers of the twentieth century."

" GG Allin was perhaps one of the most intense kinds of people who ever lived, and if you've never heard of him, check out the 1994 film *Hated*. As a punk rock singer during the 1980s for a number of bands, including the Murder Junkies, he embodied perhaps the last rebellious and antiauthoritarian stance of true rock and roll. From this perspective, his onstage antics would include nudity, bloody self-mutilation, eating laxatives and eating his own shit, as well as a self-glorified lifestyle of heroin and substance abuse. I painted this portrait of him on a really big canvas and displayed it in an exhibition in San Francisco in 2007. Everything else in the exhibition sold except for this painting, and the gallery owner was pretty down on the painting because he knew nobody would buy it. I think that's cool, because the people coming to the show would never want to put a big dirty dripping painting of GG on their wall, not only because they didn't recognize him, but because they wouldn't have been able to grasp where he was coming from. GG was totally cool and, despite my new portrait of him, he's still hated. "

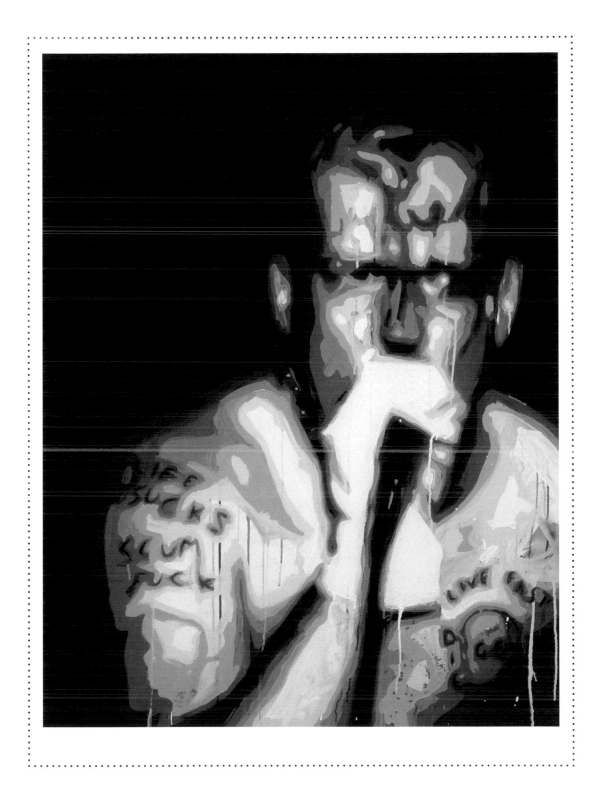

FELIX NG

www.silnt.com

Felix Ng is the founder and art director of SILNT. Apart from helping grow creative businesses and build powerful brands, Felix also continuously identifies and works closely with some of today's finest creative talents to produce projects in the form of exhibitions, publications and installations that relate to both the avant-garde and popular culture, blurring the lines between art and design. The most recent of these is the highly regarded Dual City Sessions exhibited at Design Tide Tokyo and the Singapore Design Festival, featuring twenty-eight designers from Japan and Singapore.

"Bracket," a business card for *Bracket Magazine* by Felix Ng.

"Remember to drink soup," or in Mandarin "Ji De He Tang," was a good excuse for me to get away from the computer. The idea is simple. I got hold of some very popular traditional herbs, which are used to make herbal soup—and laid out the old wife's saying "Remember to drink soup," before capturing it on camera.

CREATE AN OBSERVATIONAL ILLUSTRATION

MARCUS WALTERS

.......................➤ www.marcuswalters.com

"Sail On" by Marcus Walters.

Marcus Walters is an illustrator and designer based in the British Isles. He works in a wide variety of media creating handcrafted designs and illustrations. Marcus approaches each brief individually, often incorporating collage and drawn elements to produce simple and iconic designs. Marcus has worked on commercial illustrations for clients such as the BBC, SONY, Orange, The Coca-Cola Company, WEA Records, Amnesty International and Volvo. Marcus also art directs issues of cult magazine *The Illustrated Ape*. Marcus' artwork has been featured in exhibitions in London, Paris and New York and has been published in various books across the world.

" When sent any creative task, time is always important. Thinking can often take longer than the artwork. I look at my watch many times to check how much time I have left. I recently realized, for my watch at least, that time is running out. I have had the same watch for over fifteen years, and it is starting to become unrepairable, the casing is cracking and the functions are malfunctioning. It has been suggested that I buy a new watch but I can't bear to. There is no other watch for me; the style of my original [Casio] G-Shock is timeless. I only hope when the time eventually fades on the display that I can pick up a new one somewhere. "

DESIGN A SKATEBOARD

FRANK CHIMERO

www.frankchimero.com

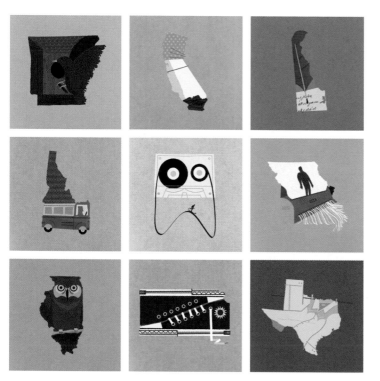

"The States," an illustration by Frank Chimero.

Frank Chimero is a designer and illustrator from Missouri. Inspired by the mid-century aesthetic, he tries to capture a sense of optimism, playfulness, heart and charm inside of his work.

> The powers that be assigned the task of creating a skate deck. The task itself wasn't too much of a stretch: Essentially, it was just a new canvas with an odd shape. The largest challenge for me wasn't with the form, it was with content. What do I put on a skate deck, as a kid that grew up on a gravel road and never skated in my life? I went around and asked some questions to some friends that I knew had skated. After talking to a few of them, I started to notice a common trend: They had all loved skating, but for some reason had stopped right around the time they all graduated high school. For them, skating still held a special place in their hearts, and the deck had come to symbolize them at that age. I wanted that for myself, so I've made a deck design that's essentially a self-portrait of when I was seventeen or eighteen years old.

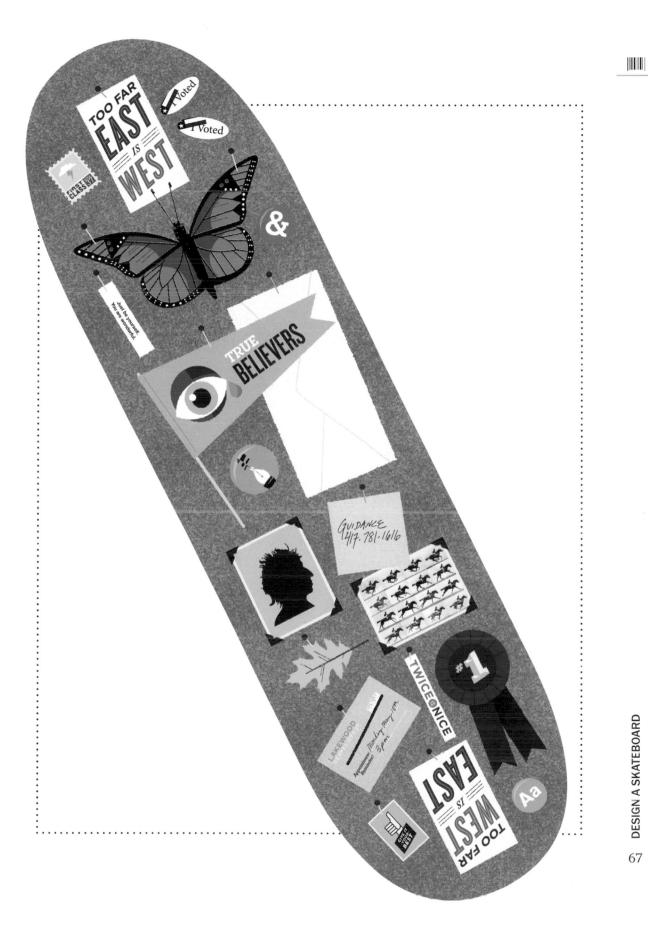

CREATE A COLLAGE

JASON TROJANOWSKI

www.jasontrojanowski.com

Jason Trojanowski first started designing flyers for punk rock basement shows in New Brunswick, New Jersey, over ten years ago. He creates fresh brands, interfaces, books and information graphics. His experience ranges from websites for Fortune 500 clients to identities for local small business owners in both agency and freelance settings. He designs with an emphasis on communicating with the user in a simple, structured and elegant way; his work does not reflect the latest trends and buzzwords. Most importantly, Jason pays close attention to the environmental impact of his projects and believes that designers should have a serious commitment to sustainability.

2008/ MLB Trades

"MLB Trade Poster" by Jason Trojanowski.

> Collage is an element of design that I last used in high school. It was an interesting concept, and I decided to run with it in a fun way but also have it be meaningful. I decided that it should be about something I am passionate about, but also be executed in a way that is unfamiliar to me. I decided to focus my collage on the water crisis that our world is facing, and the fact that by 2025, we will have a planet that is in chaos over something we take for granted. The idea of a grab bag book has been a fun and educational process. It took me out of my normal design element and placed me in a new challenge that was fun to play with.

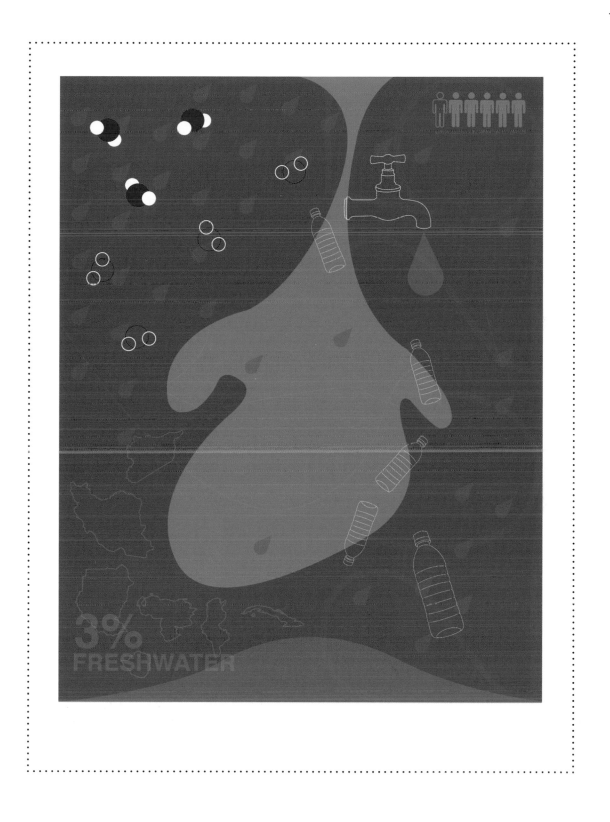

ILLUSTRATE YOUR CONSUMPTION

XAVIER ENCINAS

PETER&WENDY www.peter-wendy.com

Xavier Encinas is the founder of peter&wendy, a graphic design studio based in Paris. They like having a close relationship with their clients and living each project as a unique process. They produce many kinds of graphic projects: print, publishing, exhibition and event identity, corporate identity and anything else that makes them excited to get involved.

Promotional CS packaging by Xavier Encinas for Syntax.

" For a nonillustrator drawing ideas is not easy at all. Nevertheless, in the creative process, this is one of the fundamental steps for coming up with ideas and seeing them more clearly. When I work on my projects, I always included this step to be sure to go the right way. "

CREATE A COMIC STRIP

RICH HOLLANT, BRIAN GRABELL, CONSTANZA GOWEN-SEGOVIA, TROY MONROE AND LANNY NAGLER

········▶ CO:LAB www.colabinc.com

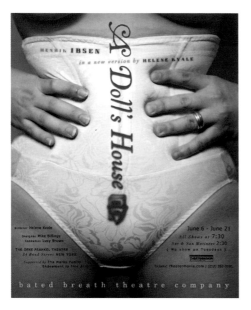

"A Doll's House," a play poster by CO:LAB
for Bated Theatre Company.

CO:LAB is a design studio, brand house and identity foundry. They create and then weave together all sorts of things that have graphic and linguistic roots, such as identity systems, collateral, advertising and interactive media. They sum up their work by saying, "Someone once said whether you're sloshing through a storm or sliding on a rainbow, a fist full of peanuts has the same number of calories. If this is true—and it is—when we meet folks ready to grow, we help them celebrate their evolution."

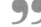

Pretty much everything evolves the same way here at CO:LAB. We take a thing apart to learn how and why it works—or how and why it doesn't—like the G4 we used to frame this comic strip. That's the easy part. The most wrenching characteristic of creativity isn't rendering an idea, but rather the elusive nature of the ideal idea. Is the project engineered with philosophical insights, with sophomoric quips fired off at scholarly speeds or with the limitless inspiration of both popular and radically unpopular cultures? That's a week's worth of dialogue right there.

A blank page can be a harrowing confrontation. Frankly, it can scare the dickens out of us. With that observation, we realized we were already executing our elusive idea while we were staring at the possibilities and the provocations of what this strip could be. We felt compelled to engage the audience in dialogue. By making our strip interactive in the form of a comic haiku, we invite the viewers to provide the piece with alternate meanings.

DESIGN A SKATEBOARD

CRISTIAN ORDÓÑEZ

www.h23.cl

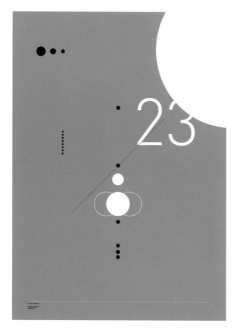

"Shape Series 01," one poster from the series by Cristian Ordóñez.

Cristian Ordóñez has worked on a variety of projects from brand identities to interactive design, for a wide base of clients and markets (including some in Canada, Chile, Denmark, Spain, Sweden and the United States), under the name of his studio H23. He is an art director at Blast Radius in Toronto, Canada. Cristian art directed a Chilean heritage project called Nuestro; they received the 2003 World Summit Award for "Best Culture Website Worldwide." He has collaborated teaching in Diploma Commissions at the Design School of the Catholic University of Chile, and is an active news contributor to design e-zines Ventilate and Onlineintercourse.

66 When I was around ten years old, I met skateboarding. I felt in love with it almost immediately. I was lucky enough to begin skating in Christchurch, New Zealand, where in my school, we had a local skate park. Great times. I got involved in design because of skateboarding. I still have my board, but don't skate every day because I focus more of my time to design, but when I can, the sensation is always unique. … This task was great and difficult at the same time. It merged both of the biggest passions I have in life that I never had the chance to unite before. My design has different meanings. I looked at it as me studying something about design or marketing—not skating—[like] I did while I was in design school; but it also means that life is only one, and you have to try to do the best out of it. The visual treatment is based on a cross pattern; the cross indicates an exact point, in this case too many points/events/situations for a life to enjoy, but it shows a young person head down, studying. 99

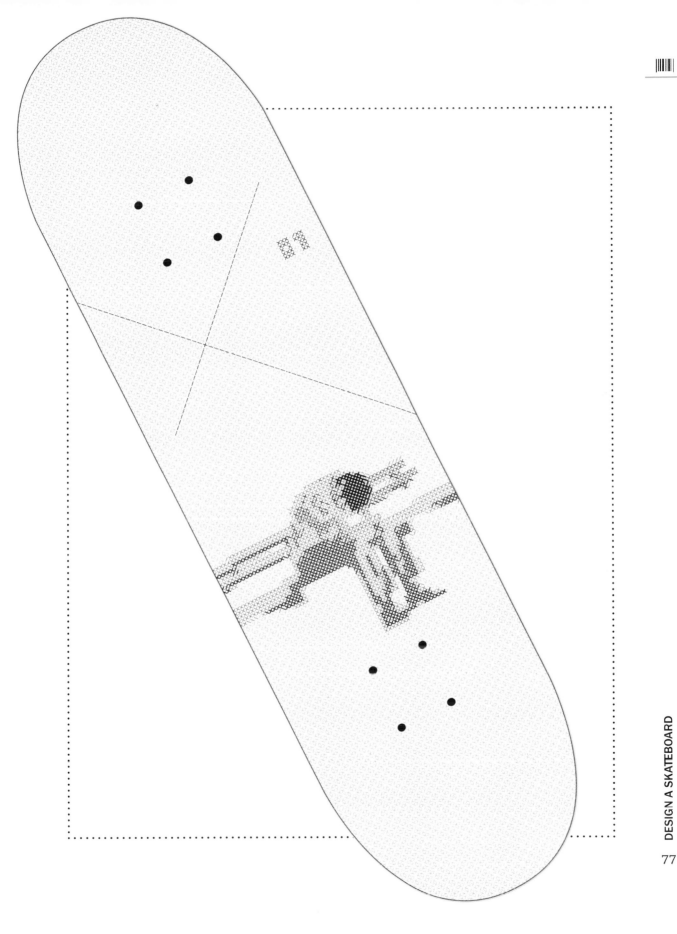

MAKE A PAINTING

DANNY GIBSON

www.djgdesign.com

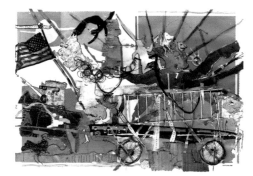

"Capture The Drag," found objects and trash on foam board by Danny Gibson.

Danny Gibson, also known as DJG, was born and raised on a farm passed down the family dirt line in the middle of Midwest America, near the outskirts of once prosperous villages now collapsed from within. Hearts and hands still celebrate the national pastimes that include hunting, playing in the creek, shooting hoops with the sheep and popping summertime asphalt bubbles with bicycle tires. His earliest input of what is now understood as design and culture trappings include: seed corn and farming logos, sports team mascots and the apple on records by The Beatles. He spent many days and nights locked in a bedroom or in a clubhouse making things—and time hasn't really changed much.

" Originally, I had the itch to paint a pile of shoes. Something about the way the shoes are slung from the feet and left for rest at the south of my kitchen table strikes my compositional fancy. However, in preparation, I found another personal pile to sift through. This being many scribbles and writings on paper scraps. I've had the means to flesh these out and decided to just up and do it for practice. "Spring Rain Wind Blows Only Truths To Expose All Those Shut-In Soups and Sandwiches Pressed Against My Clothes" was written on my walk to work one year ago. I felt the Midwest winter insulation exposed as the young spring wind blew the view for all to see. I clap loudly for signs and typography painted by hand anyway, and I typically see some on my walks. So, it was a hoot for me to play with my words further, and I plan on continuing with the rest of the paper scraps from my silly life for the remainder of my life. Besides, I think my skills are a bit too lacking to tackle a pile of shoes right out the chute with paint. "

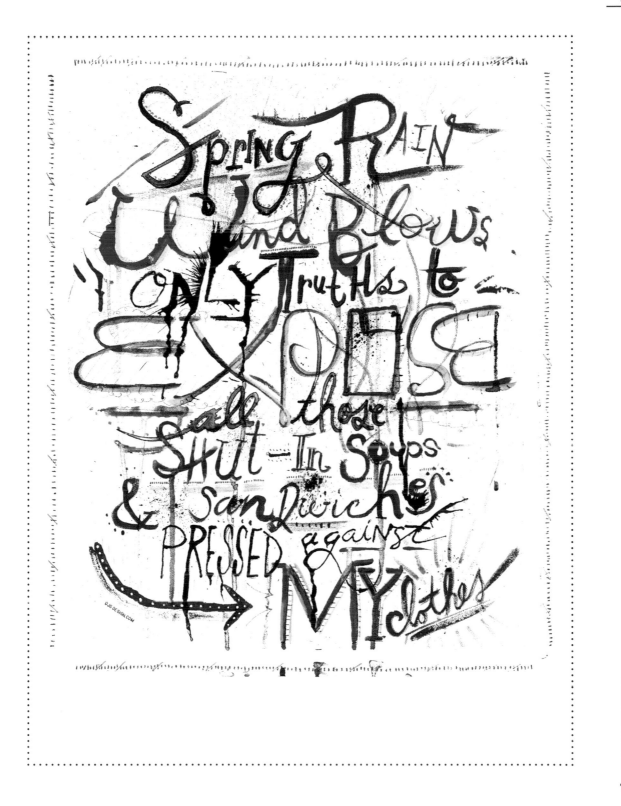

DOUGLAS WILSON

www.onpaperwings.com

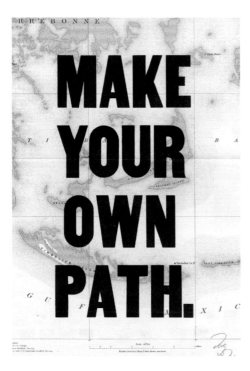

"Make Your Own Path," hand letterpressed poster on antique maps by Doug Wilson.

Doug Wilson is a multidisciplinary graphic designer, photographer, art director and university instructor who does a whole lot of letterpress printing. He hails from the Midwest in the United States. Doug grew up in Missouri—a land famous for Jesse James, summer fireflies and practical people. An avid traveler, Doug has visited forty-eight out of the fifty United States and twenty-three foreign countries across five continents. When Doug isn't busy scheming about a new print or plucking away at his banjo, you can find him enjoying the great outdoors or reading a good book. He values simplicity, hard work and honesty.

CREATIVE GRAB BAG

"I was excited to get assigned a short animation because, although I am not an illustrator, I have always wanted to create a stop-motion film. … My first thoughts went toward a complete stop-motion film created with the Lite-Brite toy from my childhood, but, as with so many things, it had already been done. Then I thought about making a film using my collection of photographic slides, playing especially with the transparency aspect (that's something I would still like to try). During the time of brainstorming for this project, my wife and I took a trip to visit friends in San Francisco. I am totally in love with flying, and I always purchase a window seat. As I was staring out the window of one of my flights, I realized that I was viewing a stop-motion film—just sped up. This led me to the idea of creating a stop-motion film where most of the film is controlled by outside sources; it's a challenge, but that is what this whole book is about."

You can see Doug's animation at www.ethanbodnar.com/books/creativegrabbag.

DIGITALLY MANIPULATE
A PHOTOGRAPH

GILBERT LEE

www.plainsimple.org

"Around Shirts," a website by Gilbert Lee.

Gilbert Lee is an interaction designer: He works with product managers to craft an online user experience. He's also a husband and a father to three princesses, which technically makes him an emperor. He was born in the Philippines and moved to Los Angeles in his early teenage years. He is of Chinese and Filipino descent. He currently lives in Salt Lake City. Gilbert credits the beginning of his love for the arts to his good uncle who supplied him with books and tools and plenty of encouragement at an early age. He hopes to do the same thing for his kids, nieces and nephews.

> I deal with imperfections every day. And that to me is a good thing. When I was given the assignment to manipulate a photograph I've taken, I turned to what I think is a constant reminder of imperfections: myself. Imperfections create opportunities for me to be grounded and to learn how to be better. Imperfections are teachers. And it is imperfections that motivate me to find perfection. Thanks to Ethan for making me part of this project. It has allowed me to pause and get out of my normal design environment.

MAKE A WALLPAPER PATTERN

DAN MATUTINA

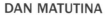 www.twisted4rk.com

Dan Matutina is currently the creative director of Idea!s, a Philippine-based social enterprise communications and design agency focused on doing advertising works for nonprofit organizations. Dan has worked on numerous materials for causes and nongovernmental organizations and has been involved in the creation of campaigns that helped the organizations tell their good stories to the world. Dan also designs toys, illustrates, oversees art direction for Gobbledygook, Inc., lectures on web and graphic design at the University of the Philippines (College of Fine Arts), blogs on social advertising at Osocio, bends forks for bracelets and illustrates speech balloon monsters.

"Balloon Wars," an illustration by Dan Matutina.

" Doing the wallpaper pattern for the *Creative Grab Bag* book project was challenging for me. I guess that's the reason why we were given tasks that weren't in our field of work, and I found that exciting! I did a lot of revisions and studies to actually come up with one that had the Balloon Wars creatures that I usually illustrate. But when I saw it again, I thought twice about submitting something that was already in my line of work, like illustrating. While browsing the web, I saw an image of a banig (a Filipino woven mat that is one of the primary handicraft products in my province) and was inspired to create a wallpaper pattern similar to it. By chance, I've been recently experimenting on using lo-fi elements mixed with futurist graphics and so used the technique to execute it. I scanned photocopied elements/textures with the grids I printed out, created composites of them in Photoshop and Illustrator. I made even the vectors imperfect to capture the beautiful imperfection of the hand woven mat. I was very happy with the result of the experiment in creating the wallpaper pattern and, at the same time, got to share part of Philippine culture with others. "

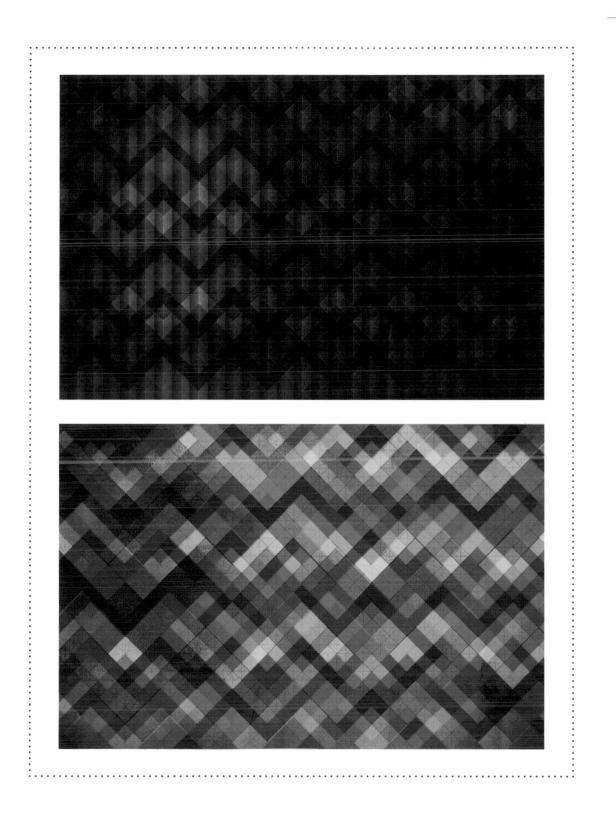

CHRISTOPHER SLEBODA AND KATHLEEN BURNS

➤ GLUEKIT www.csleboda.com

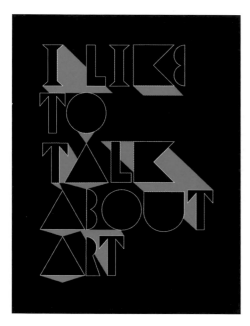

Working together under the name Gluekit, Christopher Sleboda and Kathleen Burns create images, illustrations, type and design. Their illustrations have appeared in *The Atlantic, Entertainment Weekly, Fortune, Newsweek, New York Magazine, Nylon* and *Spin*. Gluekit has also created work for Faesthetic, Urban Outfitters, Random House, Inc., Threadless and Yale University. In addition to their commercial projects, in 2007, Gluekit launched the project Part of It, which works with artists to create products involving causes they are passionate about. Part of It stems from Gluekit's belief that artists (and conscientious consumers) can make a positive difference in the world by supporting causes close to their hearts.

"I Like to Talk About Art," a T-shirt graphic for Yale University Art Gallery by Gluekit.

66 We like to consider how our various projects—illustrations, type, book design, photographic projects—intersect and collide, so this gave us a chance to collect our thoughts around our assigned task: painting! All of our studio work is collaborative, so we also wanted to conceive a workflow that allowed us both to contribute from the brainstorming and conception through the work's actual production. … Experimentation with form and medium lies at the heart of our work, and our grab bag painting task presented an excellent chance to break out our watercolors and oils, put brush to paper and create a new project while simultaneously generating textures and possible materials to work into future projects. "You're So Pretty" evolved naturally from initial discussions about this project and seemed appropriate for watercolor handmade type. We both really adore letterforms and words, so the project ended up being a love letter to handmade type as well as a fun phrase to render. We both loved the idea behind the grab bag book and look forward to seeing what other participants produced! 99

CREATIVE GRAB BAG

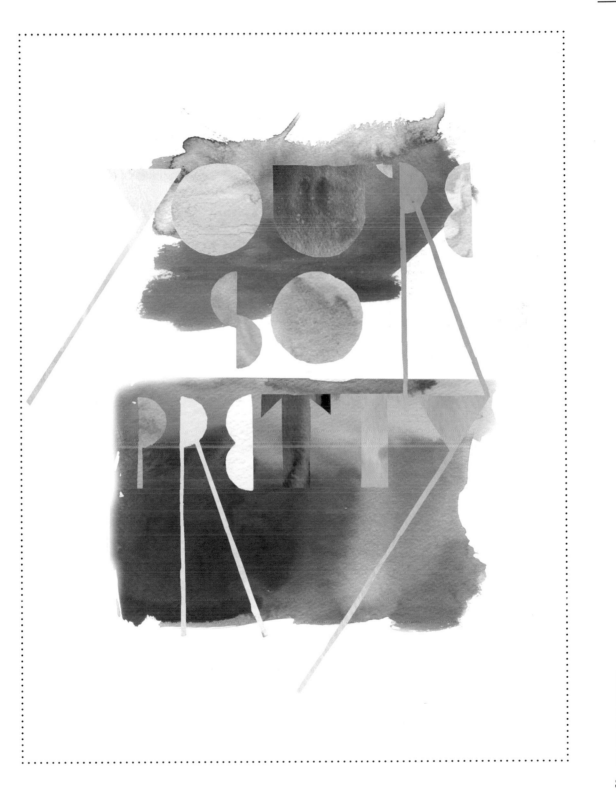

DESIGN AN ALBUM COVER

RICHARD GILLIGAN

www.richgilligan.com

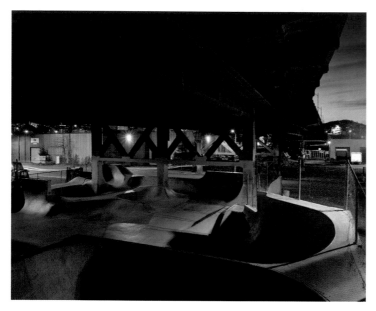

"Burnside," a digital photograph by Richard Gilligan.

Richard Gilligan is a photographer based in Dublin, Ireland. His work has been published and exhibited internationally, and he continues to pursue his own documentary projects alongside shooting commercial projects. He also skateboards.

" I was given the task of designing an album cover, which I was delighted to get as I've always been a big fan of album artwork. This gave me a chance to work on a project I would never usually explore. I always doodle, and I always like the look of things that appear to be done quite hands on so that was my approach for this project. Even though the finished product looks like it could have been done by a four year old, I'm happy with it. "

SARAJO FRIEDEN

www.sarajofrieden.com

Sarajo Frieden is an artist based in Los Angeles. Her work has been included in exhibitions in Los Angeles, New York, Rome, Naples and Melbourne, Australia. Her commissions for a wide variety of national and international clients appear in magazines, cookbooks, children's books, CDs, feature film titles, type fonts, television commercials and on wallpaper. She finds inspiration in nature, travel, Persian miniatures, Shaker trance drawings, Japanese woodblock prints, textiles, hand-lettered signs and her Hungarian great aunt's embroidery. She has won numerous awards from American Illustration, 3 x 3, Graphics, Society of Illustrators of Los Angeles, Communication Arts, New York Society of Illustrators and Type Directors Club of New York.

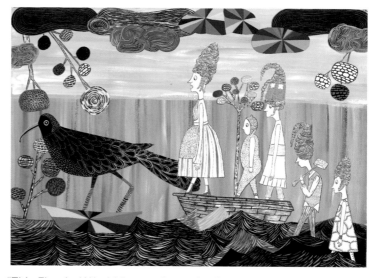

"This Flooded World," gouache and painted cut paper on paper by Sarajo Frieden.

"Exploring one's creativity … for me, that is really the point of being an artist. This Martha Graham quote speaks stongly to me: "There is a vitality, a life force, a quickening that is translated through you into action, and because there is only one of you in all time, this expression is unique. … You have to keep open and aware directly to the urges that motivate you. Keep the channel open. No artist is pleased. There is no satisfaction whatever at any time. There is only a queer, divine dissatisfaction, a blessed unrest that keeps us marching and makes us more alive than the others." [It speaks] about creativity and the artist. It is about keeping one's channel of creativity open. The "blessed unrest" of creating, that keeps one moving forward, exploring and alive."

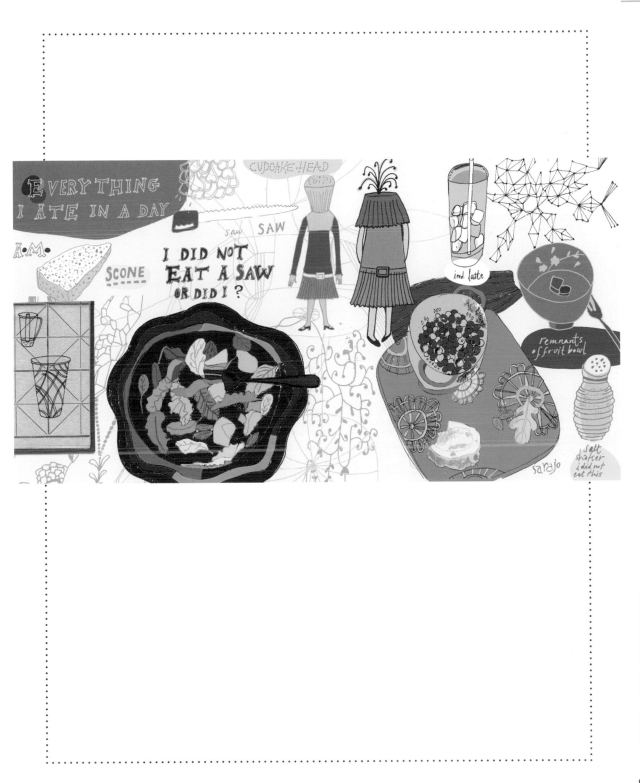

DESIGN A MAGAZINE COVER

SEAN SUTHERLAND

Sean Sutherland is a designer hailing from northern New Jersey. He has an emphasis on print design and strives to create unique, effective ideas for each individual project, large or small.

"Routine" by Sean Sutherland.

> Developing ideas for a project that you have never experienced before can be challenging, yet awesome at the same time. When I receive a new project, I will research an idea and relate it to what is currently going on in my life and/or the world around me and take it from there.

PETER KIENZLE

www.superette.de

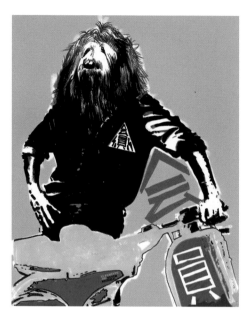

"Member," a felt pen illustration by Peter Kienzle/SUPERETTE.

Peter Kienzle has trained in Southern Germany, Berlin and New York City. While living in New York, he started SUPERETTE, an organization for illustration and art direction. Under this moniker he has worked for clients in fashion, music and editorial businesses like Adidas, Nike, Yoko Devereaux, *VICE* Magazine (Scandinavia), Black-Book and *Lodown* Magazine. In his work he combines his European sensibility with a love for popular culture. He is cofounder and editor of the zine BONUS. Now based in Zurich, Switzerland, he is enjoying the micro-urban scene, the Alps in winter and the lake in summer.

"I try to explore something fresh for every new project. Inspirations sometimes come in very unexpected ways. It might be something I see from the corner of my eye, some misinterpretation, a sound striking a visual note. From the steady onslaught of input I am refining my own visual world."

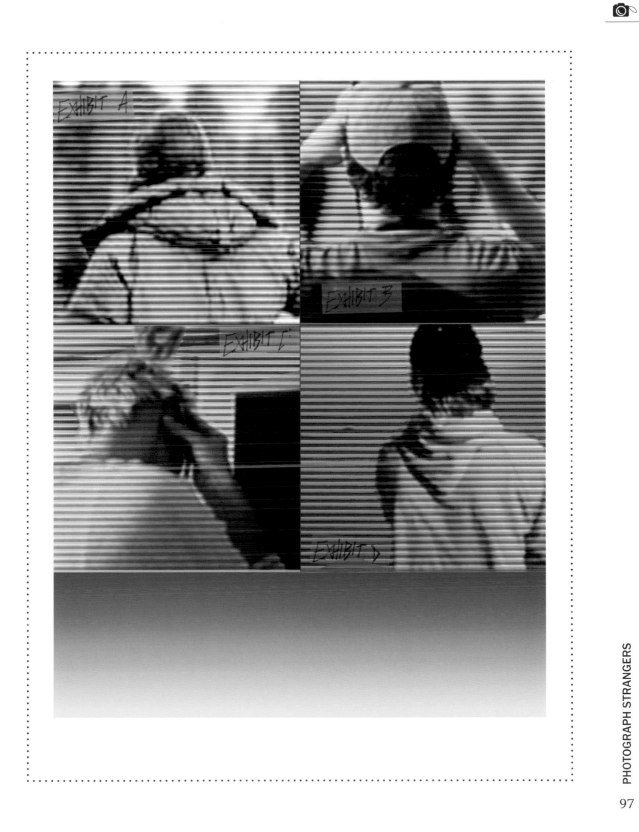

LIAM DEVOWSKI, BENJAMIN DOMANICO,
JOYCE KIM AND SAMUEL ORTIZ-PAYERO

NEON GRAY www.neongray.info

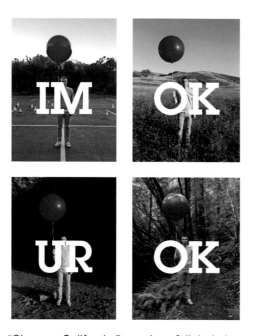

"Cheer up California," a series of digital photographs by Neon Gray.

Neon Gray is a multidisciplinary art/design group from Baltimore, Maryland, and San Francisco, California; they're better described as a kinship, based on their life-long friendships. The studio currently consists of Liam Devowski, Benjamin Domanico, Joyce Kim and Samuel Ortiz-Payero. These founding members each come from various backgrounds within an art and design education—from photography and video, to fine art and design, to interactive media. Together they benefit from their differences in approaching and creating art, as well as their bicoastal separation, to complete fresh and award-winning national projects. Their most recently completed works focus on type design, tactile design and art direction.

" Our first conversation about this project focused on what technically constitutes a collage and then how that process could translate to our aesthetic. The term collage can be very broadly interpreted, defined simply as a work of art that includes multiple elements that have been combined. We came to the conclusion that simply gluing down some found clippings to make something pretty wouldn't be enough. We wanted to create something that held meaning to us and was uniquely ours. We decided to elaborate upon an unfinished idea: a custom type illustration that read 'sadurday.' We collected various personal photographs that we felt emulated the theme of nostalgic Saturday activities and contained visual continuity. These photos were laminated onto ⅛" acrylic which was then laser-cut into individual layers and assembled. "

CREATIVE GRAB BAG

98

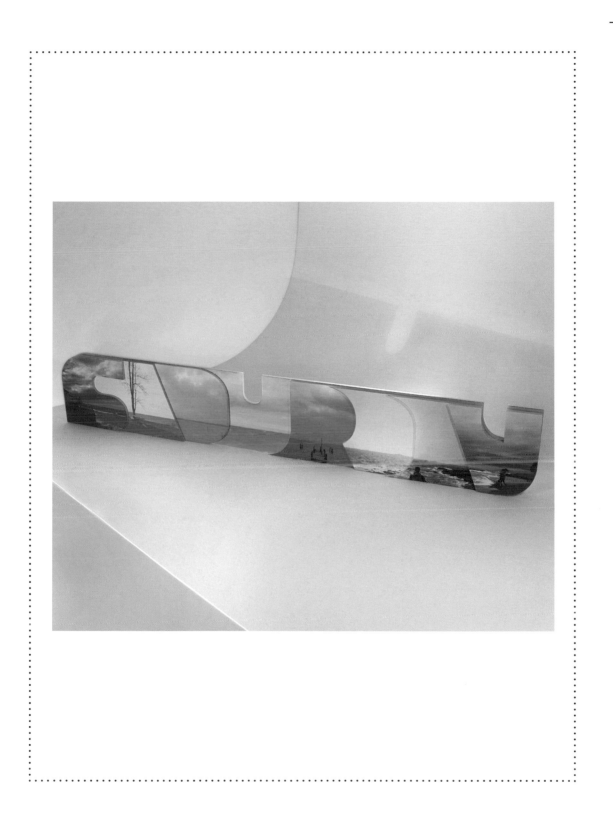

AARON HOGG

www.moadesign.net

Aaron Hogg, also know as Hogboy, is a designer and illustrator working for the New Zealand–based company Ministry of Aesthetics. He creates mainly for the international action sports and streetwear fashion industries. When he isn't pushing pixels, he is surfing, riding, running or making music. His clients include Adidas, Flow Snowboards, Kona Bikes Co., Westbeach Snowboarding Apparel, Adio Footwear, Omatic Snowboards, The Allyance Clothing, RJ Reynolds, DC Comics and Chalkydigits NZ Clothing.

"Die Yuppie Scum," a screen print for Cleatis Preston by Aaron Hogg.

" I found this experience fun and liberating. It was refreshing to be randomly assigned a subject to design for, and I was delighted with the theme I was given. "

DANIEL ST. GEORGE

www.azstar78.com

Daniel Anthony St. George 2nd, the artist formerly known as AZStar78, is a painter currently living and working in Brooklyn. His body of work encompasses thousands of drawings, paintings, prints and self-published books and zines. DSG2 is a self-taught artist who has been drawing since childhood; his work is intensely personal and deeply autobiographical. He has been an art director, designed his own line of clothing called Spiked Punch, and worked with the likes of StŸssy, the gallery Typestereo, 111 Minna Gallery, the online magazine Giant Robot and Jeremyville. His plans include creating installations and moving sculptures that will allow the viewer to physically enter the realm of his experience.

"Stalker," mixed media on paper for the Cliff Notes series by Daniel St. George.

" The work titled "What you know" is a comic script using the text from an actual existing comic. I replaced the original characters with my own imagery, and reflect[ed] of the dialogue between characters *A* and *B*. I found it to be the conversation we are all faced with daily in the great adventure of finding ourselves through someone else. The world is so large, and yet so small, so finding our place within it seems to rest in the arms of another. I find this idea amazing and frightening at the same time. The art I do deals with relationships and the entanglement we create within them. "

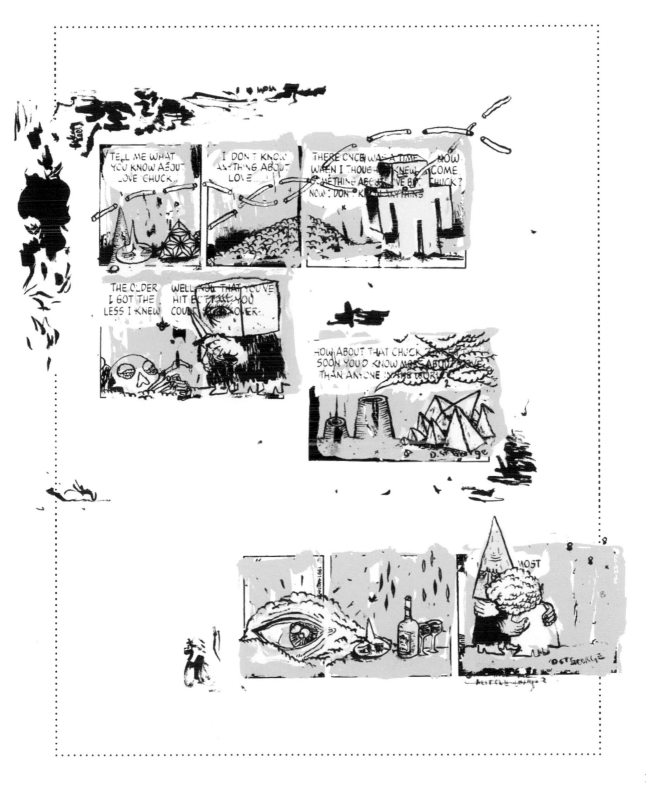

QUENTIN MARGAT

www.quentinmargat.com

NORMAL

A B C D E F G H I J K L M N

O P Q R S T U V W X Y Z

0 1 2 3 4 5 6 7 8 9

À È É Ê Ë Ï Î Ô Ù

Æ Œ Â Ä Á Å Ã Ç Í Ì Ń

Ó Ò Õ Ö Ø Š Ú Û Ü Ý Ÿ Ž

. : ; , ! ? ' " " - _

() { } | / \ * + = ‡ –

€ £ @ $ %

"Normal," type design by Quentin Margat.

Quentin Margat was born in February 1986. As a child, he used to draw every day, especially customized castles and impossible multi-floored pirate boats. Later he discovered graffiti art. From those years, he learned the necessity to sketch hard to get the perfect shape and discover the interest of the generative pressure into creative task. His love for the letters probably began at that time. He is currently a student in graphic design and is especially interested in font design.

"One of the various interests of design is that it is not an art. Design must be related to a demand, a problem and a user. I like to put my creativity under the pressure of a specific task; it's very challenging. I feel really unable to create without any imposed or preexisting demand. Currently, I am not looking for complete freedom into my work; maybe it will come in a few years.

For my creative task in the book I wanted to use only typography. I tried to draw in a very expressive way, considering the typographic element as an image."

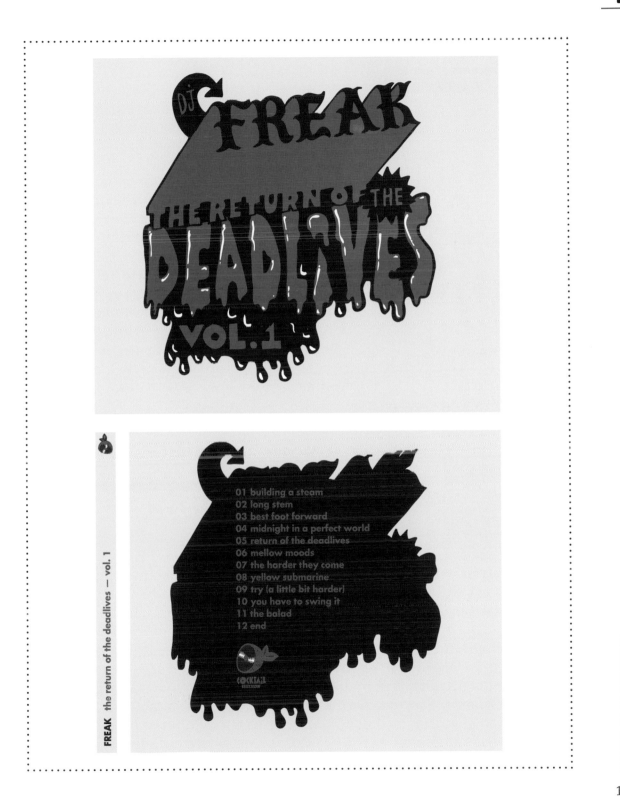

NATHANAEL JEANNERET

www.onetonnemusic.com/graphic

"Medusa," a gig poster for Doherty's Bar by
Nathanael Jeanneret.

Nathanael Jeanneret is a graphic designer based in Hobart, Tasmania. He's done retail design work and can put together an advertisement for big TVs and couches faster than he can cook himself breakfast. Fortunately, he realized that life isn't all about selling fridges and started to do gig posters a few years ago to breathe a bit of life into his design career. He now enjoys gig posters more than any other design task. Recently, he has focused on developing his creative skills and chasing the dream of being a full-time gig poster designer. He loves music and loves to work in Illustrator, limiting himself to the pen tool and not much else.

> It's so much harder to do a job for yourself than to produce something for someone else. The creative restrictions that come with working on artwork for a client or a business mean that when you don't have those restrictions, you feel a bit lost. It was really nice to be able to leave some empty space on a page and let it sit—more often than not I get told that a particular piece of information has to be bigger. Just having no other responsibility than leaving me happy has made this an enjoyable process for me. It's hard to break out of the rhythm of doing things in a particular way. This project has challenged me to strip back my normal bold style and also to boot up Photoshop for something creative (normally, I use Photoshop as a tool to fix or edit pictures), and I didn't see it in the same way I saw Illustrator as a creative outlet.

CREATE A PHOTO ESSAY

BEAU BERGERON

http://beaubergeron.com

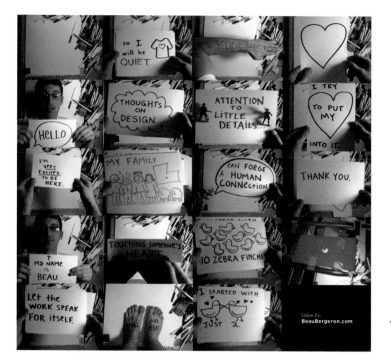

video by:
BeauBergeron.com

Beau Bergeron is a creative designer working with IDEO in Chicago. He is originally from Louisiana and a recent graduate of the University of Florida. Beau is working really hard to battle his quarter-life crisis by pursuing such endeavors as founding and continuing the Great Underwear Dash (a biannual event that mixes flash mob with charity), making more viral work, starting a dance club in his basement (even though it may be haunted), returning to screen printing (the reason he got into design) and staying fly.

"Catch the Wind: Interview Video for IDEO" by Beau Bergeron.

" Being creative is like being in shape. I'd like to be a marathon runner (creatively), but I'm afraid I have recently grown flabby. I decided to work with black-and-white film, but I struggled to take any one photo that really felt right. My dark room strategy is pretty much to fumble around in the dark until something cool happens. I decided to try my hand at drawing giant photograms since I like to be hands-on whenever possible. I took my photos from a *Great Gatsby*–themed party and blew them up. I drew in reverse on transparencies with a grease pencil basically creating letter-sized negatives. I tiled the resulting prints together to create these black-and-white portraits. I was really pleased with the result. They sort of have a linocut quality, which is cool because I like to blur the lines between mediums and aesthetics. "

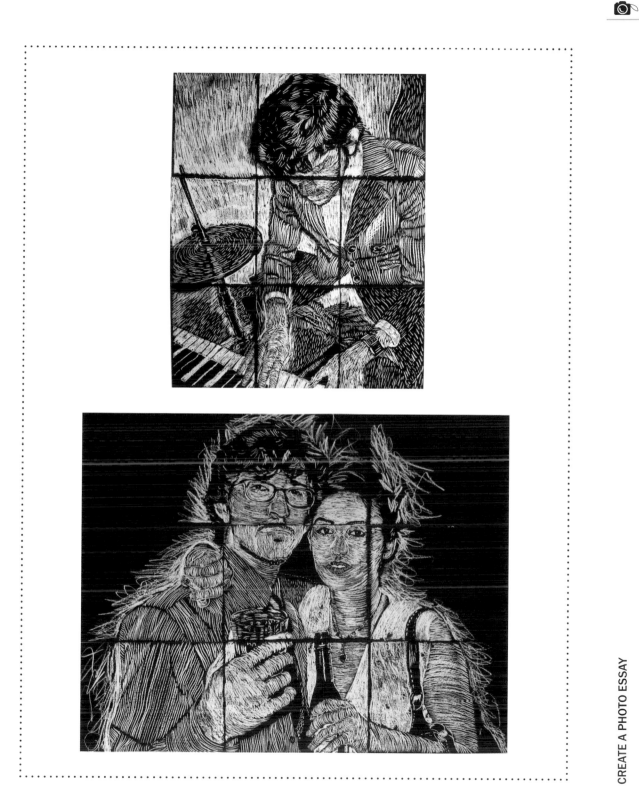

DESIGN AN ALBUM COVER

FABIEN BARRAL

www.imoments.org

Fabien Barral is a graphic designer and photographer who is passionate about image and graphic design. He has a house in the countryside of Auvergna, France. He is the author of the blog Graphic-ExchanGE. He believes that he is not the clients he works with, but he is the projects he does with them. He is what he creates. He creates what he is.

Harmonie Intérieure catalog by Fabien Barral.

> Doing a creative task like this is nice because you do not have to follow a brief, or follow other people's ideas. It is your own; you do it just because you want something nice, but it is maybe too easy. Doing a very creative thing for a client is harder and much more challenging.

CREATIVE GRAB BAG

116

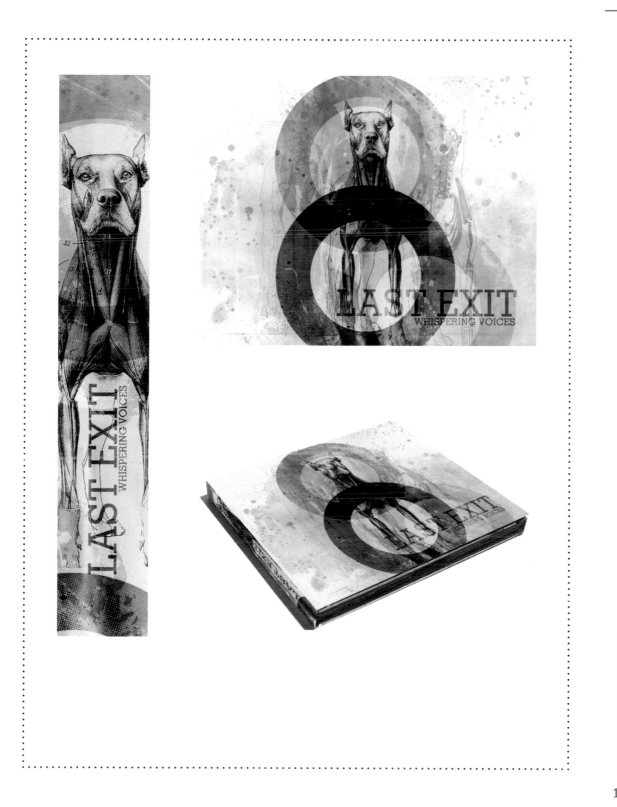

NEVADA HILL

http://nevadahill.com

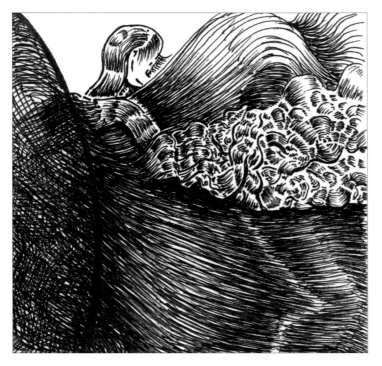

"Appendage," watercolor by Nevada Hill.

Nevada Hill graduated from the University of North Texas with a BFA in printmaking and a minor in sociology. During his time there, he was in several experimental music groups around Denton, Texas, in which he would make lavish hand-drawn gig posters for events. Now he is a sole proprietor of his own business where he prints posters, CD packaging and T-shirts and charges little or nothing for some customers. He also runs a small CD-R imprint called Mayyrh Record with his bandmate Michael. He and David Price also have a small zine publishing label called Cornkitdotnot. They have already released a collaborative half-page zine that goes by the same name and a mini-zine called *Mass vol.*

"Being comfortable in the process of creation makes me anxious. A way to make myself break out of my comfort zone is to experiment with other mediums or imagery that I'm usually afraid to utilize. I realize that squirming and being incredibly frustrated ultimately creates an end that I will be content with farther down the line."

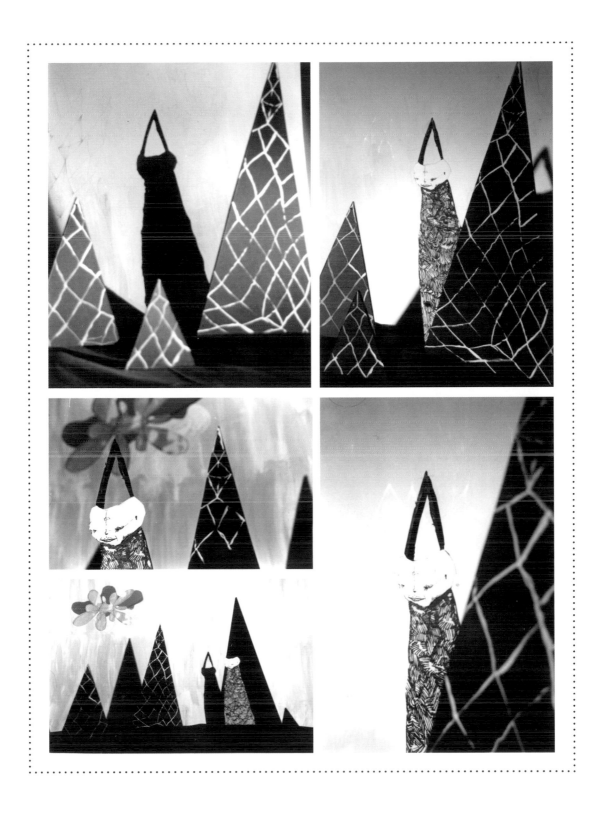

MATTHIJS MAAT AND KIM SMITS

········▶ **MAKI** www.makimaki.nl

"Don Was Here." ballpoint on canvas by MAKI.

MAKI is a small design and illustration studio based in the Netherlands run by Kim Smits and Matthijs Maat. Their work can be described as wacky, edgy, humorous, urban and intelligent. It looks good on almost everything, from clothing to posters, from walls to human bodies.

"We had fun with our creative task for this project. We've chosen to paint on a large canvas. Something we don't usually do. Our work is usually created using small ballpoints at a maximum size of A3. The theme for this work is underdogs; we've always had a thing for them. It relates to high school where there seems to be a big gap between the popular people and the so-called losers. In reality, everyone is a loser in some way and a hero too."

MAKE ART LIKE A CHILD

MAURO GATTI

www.mutado.com

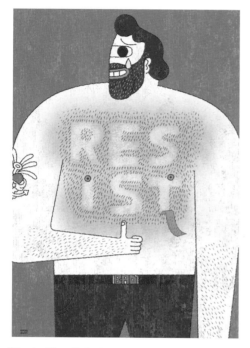

"Resist!" a digital poster for !RESIST! Exhibition by Mauro Gatti.

For over a decade Mauro Gatti has been at the forefront of new media design in Italy. Humorous, sharp and creative, his work has been globally recognized. In 2004, Gatti cofounded Mutado, a creative studio with offices in London and Milan. He began his career as an interactive designer in the mid-90s and became highly influential through his personal web site The Brain Box (www.the brainbox.com). He has worked on projects in new media, motion graphics and branding fields. His main passion is illustration; he loves to make drawings that capture the more comical side of life. He has developed work for MTV, Nike, Comedy Central, Paramount Comedy, Nickelodeon and Disney.

> " Working on this assignment has been so funny! I had to draw like a child and even though it hasn't been very hard because I still draw like [I did] when I was six years old, I tried to express my creativity as if it was made through the hands and eyes of a child. Humor has been one of the most important things in my life since I was young, and I hope that my creation reflects my love for fun. "

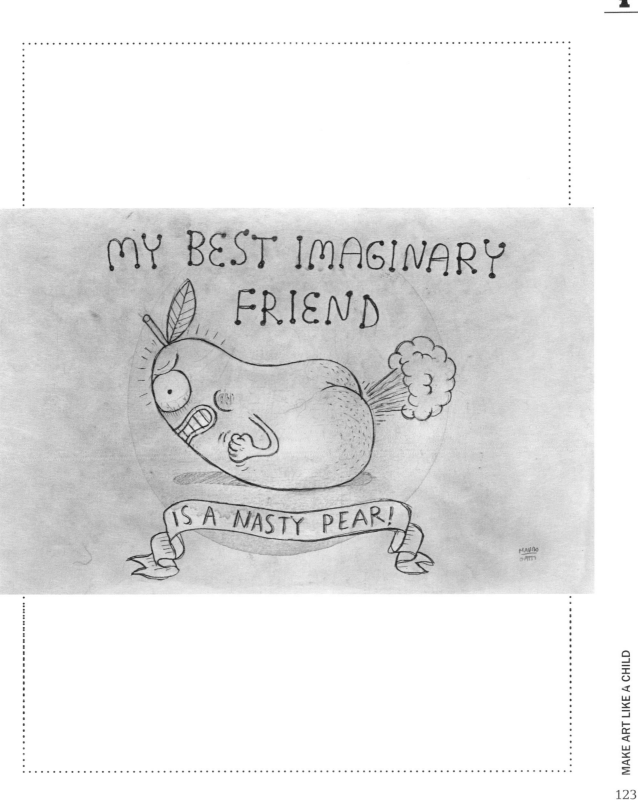

CREATE AN INFORMATIONAL GRAPHIC

AARON JAMES DRAPLIN

www.draplin.com

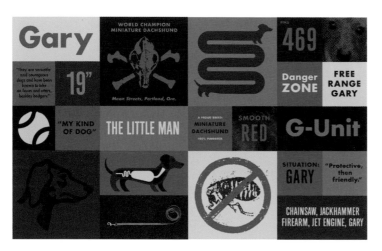

"Gary Postcard," a promotional card for Draplin Design Co., Gary Division by Aaron James Draplin.

Born in 1973, Aaron James Draplin is a graphic designer. Located in the mighty Pacific Northwest United States, the freedom fighters of the Draplin Design Co. proudly roll up their sleeves on print, identity, web, illustration and Gocco muscle projects. He spends his free time with his dog, Gary, collecting records, driving down the open road, playing the guitar and pursuing the American dream.

> "About three years back, I added a dog to DDC Factory Floor. A little dachshund (commonly known as a Weiner Dog) that goes by the name Gary. Long and lean, the little man is a handful, and has added a complete range of joys, frustrations and burning mysteries to my life. So, I thought I'd focus on him with this project. Like any thorough statistical exercise, the regimen of exploring every detail of the G-Unit offered many new perspectives to our bond. I'm amazed at just how many sides there are to Gary's little existence. Every one of my friends has a special name for him, and in the process of itemizing them into a list, it made me realize just how many people he touches day to day. While analyzing the impact he's had on my life, I can't help but choke back a couple tears. I fell for the little shit the moment I laid eyes on him. He's a big part of me, and it's been an honor dedicating a page to him."

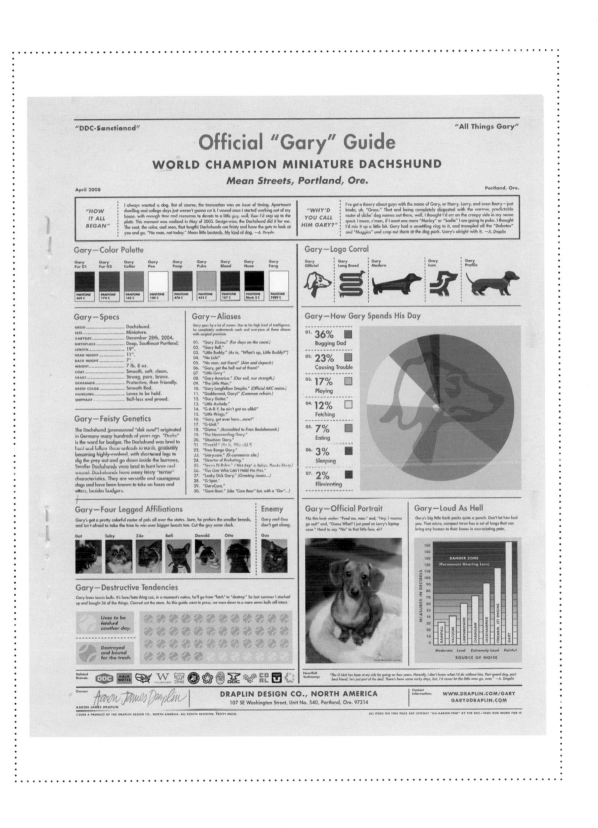

DESIGN A PAIR OF SHOES

OLIVER MUNDEN

MCFAUL http://mcfaul.net

McFaul is a multidisciplinary design guided by lead designer, Oliver Munden. Touted as one of the zeitgeist of UK contemporary design, they pitch their considerable talents across a huge spectrum of creative outputs big and small. McFaul specializes in graphic design, illustration, motion graphics, brand and identity; but they actively encourage the challenge of any media. They have recently created TV commercials for clients like Specsavers, store refits with both Carhartt and Nike Air Jordan, over four hundred meters of continuous vinyl graphic (not to mention seven bus wraps), and multimedia campaigns for Toshiba. They also restyled Liverpool John Lennon Airport. They are unquestionably riding the crest of their creative energy.

"Havaianas Campaign" hand painted for BBDO-New York by McFaul Studio.

> What was the point of doing [this project]? It was a challenge to draw on a three-dimensional canvas that didn't take the ink as well as a piece of paper does. Not smudging something you've drawn already was also difficult. But we really enjoyed depicting an octopus engulfing the shoes with his huge eyeball on the front, creating a big chaos of octopussage!

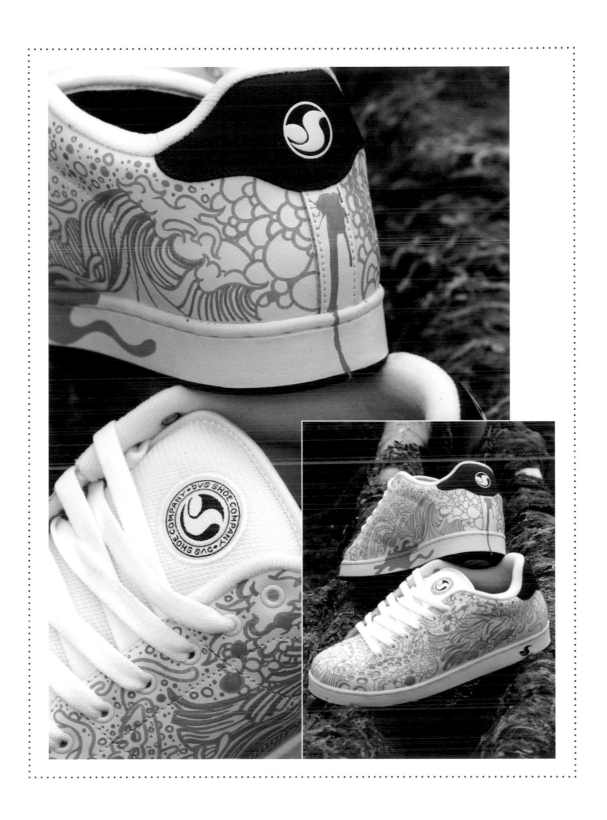

DESIGN A BUILDING

MICHAEL GILLETTE

www.michaelgillette.com

"Untitled" by Michael Gillette.

Michael Gillette is a San Francisco based artist, originally from Great Britain. He has worked with Beck, the Beastie Boys, Levi's, Nokia, *The New York Times*, *Spin*, *Rolling Stone*, and Greenpeace.

" [It is] an attempt to trap some of the city's attitude and feel in a building. Skyscrapers are such a modernist conception and Victoriana is clearly completely at odds with that ethos, so I thought it'd make an interesting clash. "

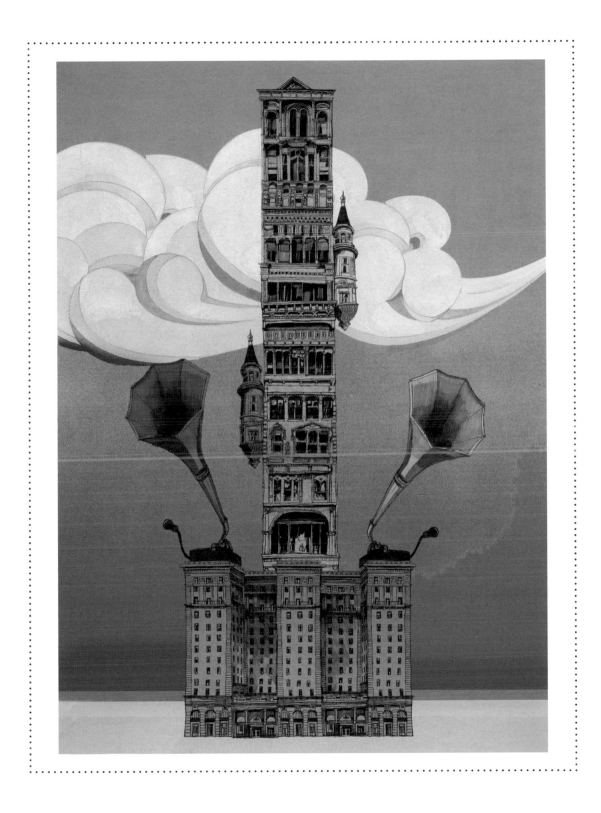

DESIGN A SKATEBOARD

MICHAEL PERRY

www.mikeperrystudio.com

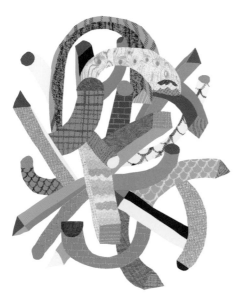

"Exploding Shapes," a screen-print by Michael Perry.

Michael Perry runs a small design studio in Brooklyn, New York. He works with clients like MTV, Brooklyn Industries, *Dwell* magazine and *The New York Times Magazine*. His first book, titled *Hand Job* and published by Princeton Architectural Press, came out in 2007 and his second book, *Over and Over,* was published in 2008. Doodling away night and day, Perry creates new type-faces and sundry graphics that inevitably evolve into his new work. He has shown his work around the world, from the booming metropolis of London to Minneapolis to the homegrown expanses of Kansas.

" I think of creativity like exercise, the more you do it the stronger you are. I believe in the making of piles as the most sincere part of the creative process. And I live by the motto of Make, Make, Make! Those three things find their way into everything I do. Sometimes it works, and sometimes it doesn't but that is part of the fun. "

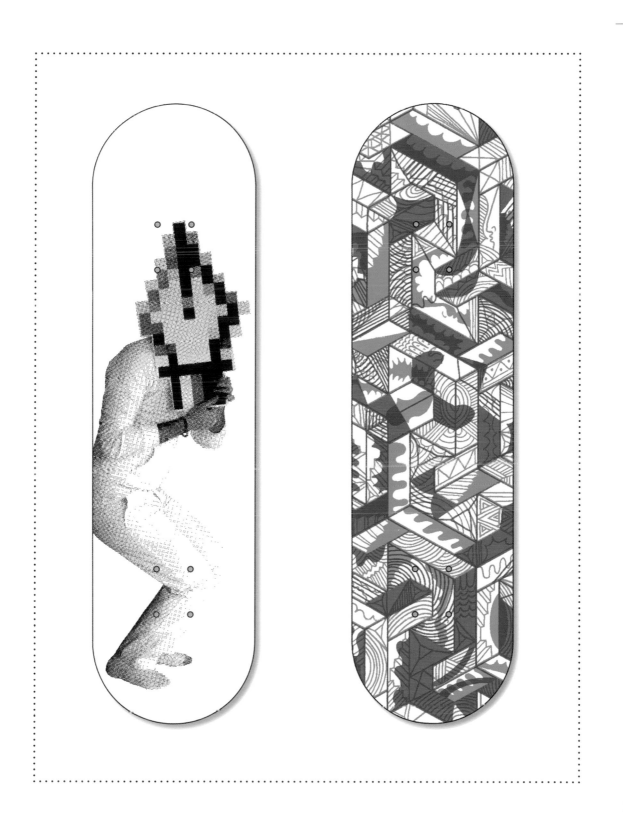

CREATE A PHOTO ESSAY

JODIE DAVIS AND DAVID PARINGTON

PESKIMO www.peskimo.com

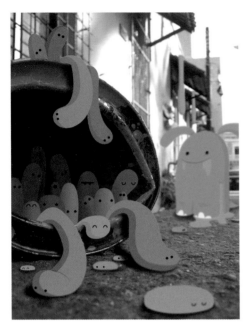

"Mañana Mazatlan," photograph and vector artwork by Jodie and David of Peskimo.

Peskimo is made up of Jodie Davis and David Parington, who met at Leeds Metropolitan University. They graduated in 2002, Jodie in graphic arts and David in design and multimedia technology. Their work is a colorful, imaginative world full of monsters and cute animals, pattern and texture, fun and frolics. They find inspiration from cartoons, vintage graphic design and the oddities of everyday life. They hope one day to own their own ice cream van.

> There's nothing quite like an ice cream on a summer's day. It's a great British tradition to eat ice cream, especially from an ice cream van at events in the summer months, the whippier the better with a chocolate flake! It doesn't matter if it's a wet and wild day in July, you can't beat cool ice cream refreshment. 1. Everyone likes ice cream! 2. Pop into the ice cream café for a snack. 3. Industrial ice cream. 4. Even plastic ice cream looks appealing. 5. Kids love ice cream!

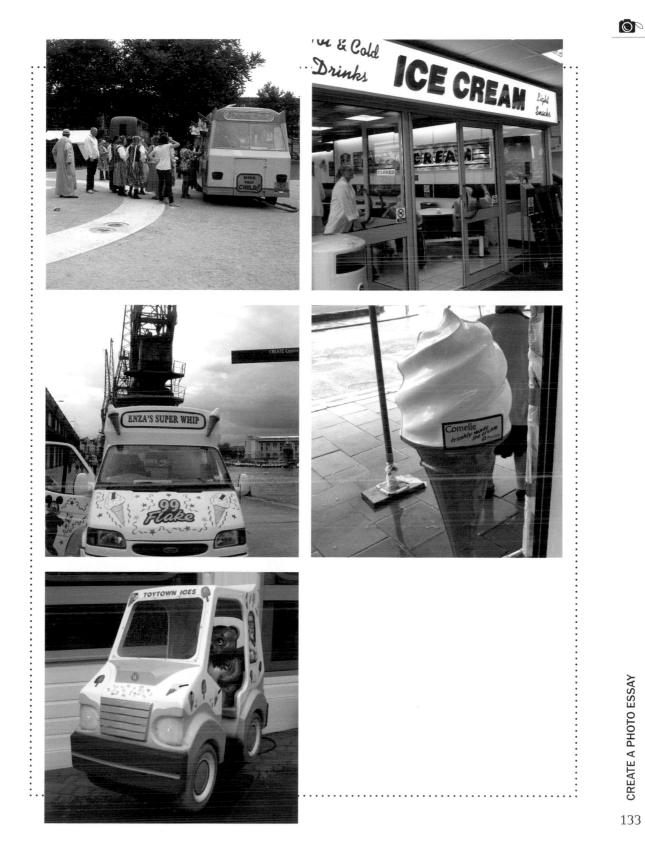

CREATE A COLLAGE

LINZIE HUNTER

www.linziehunter.co.uk

"Supermarket," digital illustration by
Linzie Hunter.

Linzie Hunter is a freelance illustrator and lettering artist. Her work is often influenced by her love of all things vintage, and any spare time is often spent hunting down paraphernalia from the '50s and '60s. Her lettering and illustration have been used in books, magazines and advertising campaigns internationally, and her clients include: *TIME* magazine, the *Guardian*, Soy Joy, Gillette, Sonic, BBC, Random House, Bloomsbury Publishing, Penguin Group and Little, Brown Book Group. Linzie's first postcard book, *Secret Weapon*, a series of typographic images based on the subject lines of spam e-mails was published by Chronicle Books in 2008.

" As a digital illustrator, a large part of my day is spent stuck behind a computer screen, so I was more than happy to select a traditional collage from the grab bag. In an attempt to fully embrace the old-school aesthetic, I chose to create a piece involving lettering and illustration without the use of my computer at any stage. Choosing a Fifties/Science theme, I mixed paper-cut lettering with collaged images and typography from the ever-growing pile of vintage ephemera in my studio. Charity shop supplies—wire, stickers, old rubber stamps and dry transferable lettering—were all put to good use, too. My only small concession was the use of an old analogue photocopier, which I picked up for £1.50 ($3) on eBay. It's ancient and can't enlarge, but it was handy for those items I couldn't bear to cut up. While I found the process incredibly (and unexpectedly) time consuming, it played as a reminder not to rely too heavily on digital technology in my work. Overall, a good challenge for me—both frustrating and liberating in equal measure! "

Randy J. Hunt is a designer and entrepreneur who holds an MFA in design from the School of Visual Arts. In 2005, he founded Citizen Scholar, a design studio that collaborates with social entrepreneurs, educators and artists. His clients include Do Something, Worldchanging, AIGA, School of Visual Arts, Broadway Across America and Japan Society. The studio promotes stories of community action and social change through a web site and events known as The Amazing Project. A cofounder of Supercorp, Randy designs web tools focused on enabling creative commerce for small businesses. Supercorp's products include Supermarket, a curated marketplace for independent design. He is a contributor to the design blogs Speak Up, AIGA/NY's DESIGNY and Notes On Design. His writing and interviews appear in Voice: AIGA Journal of Graphic Design, *Lemon* Magazine and other publications.

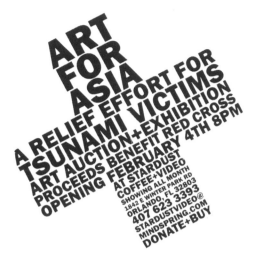

"Art for Asia," a poster by Randy J. Hunt.

July 24, 2008: Typography, grids, copywriting and code are my favored tools. I'm rarely one to make illustrations and, of late, not one to use them much either. I'll employ one of my other favorite tools to get me started, a list of arbitrary rules: Schedule a text message to remind me of the assignment; when I receive the text, identify the subject to observe and illustrate; the subject must be visible from where I am the moment I receive the reminder; I can spend no more than thirty minutes on the illustration; I can only use tools on my desk.

I'm not certain the output will be design, but the situation that has created it has been carefully designed to include both rigid rules and plenty of room for interpretation. Come to think of it, that's quite like this book.

August 19, 2008: I received the text message today. I was sitting at my desk. Nearby was a chair an officemate had placed a plant on. I remember once hearing someone describe how a chair is really just a shelf for your body."

CREATIVE GRAB BAG

design history shelf

MAKE A PAINTING

PAUL PAPER

IT IS BLANK http://itisblank.com

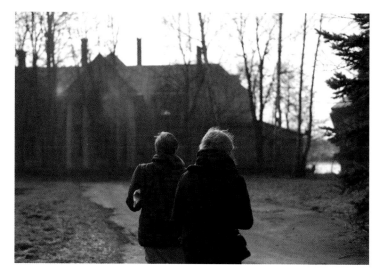

"Brave enough (for the haunted mansion)," a type C print photograph by Paul Paper.

Paul Paper lives in Vilnius, Lithuania. He has been shooting since the age of fifteen when his aunt gave him her camera. He has had work exhibited worldwide and published by various magazines. Paul shoots spontaneously, capturing what he calls "the tiny, tiny miracle in boring every day." Some moments stick to your mind in a strangely fugitive way. So do Paul Paper's photographs; there is always something on the verge of disappearance in Paul's pictures that make them reminiscent, as if expressing familiar feelings. His transition from recreational to professional came gradually. Thanks to collectives like Young Photographers United in Belgium, he is getting worldwide exposure.

❝ I really like the idea of this book. Exploring creativity by giving an artist a task that is not from his main field is a nice way to take the creator from behind. When I read the list of grab bag tasks, there were few that I really wanted to get, like to make an album cover or draw like a child. However, I got what I got and that's the part of the fun. And I had fun doing this! ❞

CREATIVE GRAB BAG

138

PAUL OCTAVIOUS

www.poctavious.com

"Seek Shelter," a photograph by Paul Octavious.

Paul Octavious is a self-taught photographer from Connecticut. He never intended to make a career out of photography. His foray into photography grew out of the need for inexpensive stock photography to incorporate into graphic design assignments. It is now coming up on his third year as a professional photographer, and he couldn't be more pleased with his career. He has been featured in publications like *JPG* Magazine and *Popular Mechanics*. He currently resides in Chicago as a freelance graphic designer and photographer.

"To see design in everything is a gift I don't take lightly. The way I explore my creativity is through constant experimentation. Whether it's a different way to play with light or post processing, I try to keep it fresh. I call it the 'Why Not? How come?' When you come up with ideas that seem far-fetched, just ask yourself, 'Why Not?' Your mind starts to figure out a solution, and more times than likely for me, I get the end result I thought was impossible. My creative task was an awesome surprise. The reason being, I sometimes forget I was educated and trained as a graphic designer. I have been pursuing photography for the past three years and have put graphic design on the back burner. This task brought it back in the limelight for me and showed how much I miss sitting in front of a computer using Illustrator, not saving, then crashing, getting pissed and coming up with a better creation than I had before. Gotta love it."

CREATIVE GRAB BAG

140

CREATE HAND-DRAWN TYPE

JŪRATĖ GAČIONYTĖ

www.amazingtreehouse.net

Jūratė Gačionytė spends most of her days in Vilnius, Lithuania, wandering around the city by bicycle. She likes having picnics on the hill, putting her feet in the river, laying under shade trees on sunny days, taking pictures of beautiful and strange surroundings. That's how she finds her inspiration. At the moment she is working as a freelance designer and illustrator. She has worked with such clients as: *Frankie* (Australia), Jersey (Germany), Japanese Embassy in Lithuania, Vilnius Academy of Arts (Lithuania), *Sutemos* (Lithuania) and Meno avilys (Lithuania). She has work published in: *Frankie* (Australia), *Katalogue* (United Kingdom), *Belio* (Spain), *Galleri* (Honk Kong), *Blanket* (Australia), Pravda (Lithuania) and Juxtapoz (United States).

"Voyage 2," a drawing by Jūratė Gačionytė

" I think everybody has got creativity—bursting, hidden, in one thing or another. It is good to play and experiment with yourself in different creative fields. It may be a challenge, fun, a surprise, an inducement. "

qwertyuiop
asdfghjkl
zxcvbnm

QWERTYUIOP
ASDFGHJKL
ZXCVBNM

i feel weird

CREATE AN OBSERVATIONAL ILLUSTRATION

ANDREAS SHABELNIKOV

www.sensegraphy.com

"Angels" by Andreas Shabelnikov.

Andreas Shabelnikov is a creative director of The Underworld Kingdom agency and chief editor of the online design community, Digital Abstracts. Andreas has been actively working in the industry since 1999 under the alias Sensegraphy for a variety of clientele including Paramount, Universal Studios, Legendary Pictures, Samsung and Palmolive.

"For the art piece, I tried to create something modern, following today's design trends seen on many different popular art pieces, by mixing together a few photographs, adding some depth and emphasizing it with shadows and lights. In every step of the creation process, I remained conscious about what it is that makes art modern and, in turn, popular. Using those techniques, I created something for the book, but personally, I believe my own style to be quite different."

CREATE A SCULPTURE

TOMMY KANE

http://tommykane.com

"Cords" by Tommy Kane.

Tommy Kane discovered drawing at a very early age. He discovered *MAD* magazine, which became his learning manual for the next decade. Unfortunately, he didn't have any formal training until he went to college. Once in art school at Buffalo State College, he was able to concentrate on drawing full time and began to rapidly improve. Focusing on developing his drawing was harder as an illustrator for an ad agency in Manhattan, where he became an art director and started to make lots of dough. There he cranks out print ads and commercials for people like IBM, *LIFE* magazine, SONY, Liz Claiborne, Steve Madden and yellow tail wine.

" My day job is an art director in advertising. The rest of the time, I am drawing and painting like a mad man. I fill journal after journal with my drawings from the streets around the world. My blog is constantly updated with new works of art. The challenge for this book was quite interesting to me. Sometimes I get in a rut with my art, always doing the same type of things. Not being much of a sculptor, I tackled the project more with my head than with the brute force it would take to create a great sculpture. Anyway, I think it came out pretty good. "

147

DESIGN A TYPEFACE

VEERLE PIETERS

www.veerle.duoh.com

Desktop illustration by Veerle Pieters.

Veerle Pieters is a graphic and web designer based in Deinze, Belgium. Her journal is a popular online source for topics ranging from XHTML-CSS and ExpressionEngine tutorials to graphic design tips and tricks and personal impressions. Starting in 1992 as a freelance graphic designer under the name of Duoh!, Veerle worked on print oriented projects before moving into designing web sites and user interfaces. In 2000, Veerle founded Duoh! n.v. with Geert Leyseele. Drawing has always been her passion, along with listening to soulful, funky, jazzy, chillhouse tunes and indulging an inexplicable fascination for the Balearic isle Ibiza.

"Finding the right direction, in terms of style, was a bit of challenge. I wanted to create a typeface that would really reflect my personality and my design style. Problem is that I love so many different styles of typefaces. I wondered what my starting point should be in terms of style. Should I go for a sans serif font with minimal lines and shapes, or should I go for a more script style? One of my favorite typefaces is the Chalet font family (from House Industries), which is used on my personal web site and for the logo of my business. It reflects my design style. I also love the Suburban typeface (from Emigre). If you look at this typeface, you'll see that I've been influenced by its rounded forms and the loops used in the m and w. It has some script style features in it, but it's not a script typeface at all. I decided to add script features in my typeface as I believe this type of style would suit me perfectly. My goal was to reflect some of my personality and my design style in this typeface, and so I did, and this is the result. "

abcdefghijklmn
opqrstuvwxyz
ABCDEFGHIJKLM
NOPQRSTUVWXYZ

· · · · * · · · ·

0123456789
!@#$%^&*()

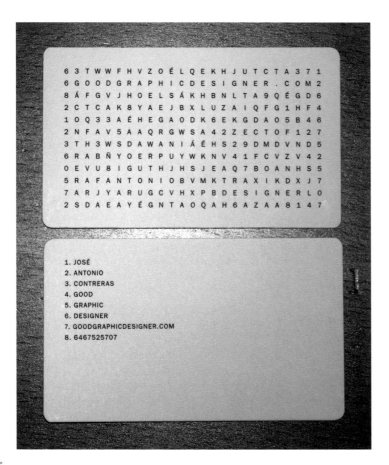

José Antonio Contreras was born in the city of Chihuahua, capital of the northern Mexican state with the same name. He attended The University of Texas at El Paso, where he majored in graphic design. Soon after graduation, Jose moved to New York where he currently lives and works. His clients include The Metropolitan Opera, the Public Theater, The 92nd Street Y and The World Financial Center. Aside from graphic design, Jose really loves taking photos, playing basketball and listening to heavy metal. He has recently become a foosball player and hopes to beat Paul Sahre one of these days.

"My Business Card" by Jose Contreras.

> I think this book is a great idea. As people in the creative industries, we all have our comfort zones, and it's always good to push ourselves beyond them. In my case, I think I got one of the most difficult assignments, but I think I did well. I believe I have a good eye for photography, and I've been trying to get more serious at it, so my creative task came at the perfect time! I really wanted to make my photos as much about a story as possible, as opposed to just a sequence (it's hard with just four frames). I'd like to thank Nicole Van Leight and Jonathan Tichler for assisting me in the creation of these images.

CREATIVE GRAB BAG

150

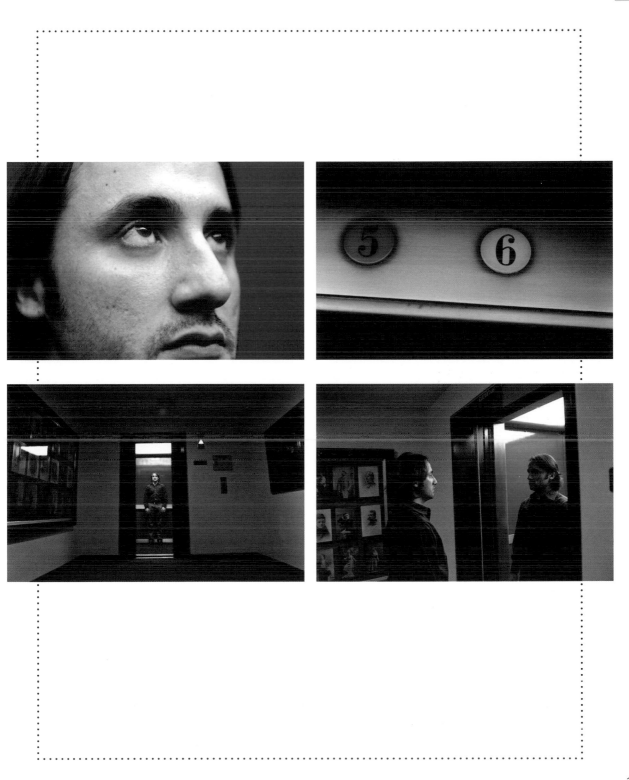

ILLUSTRATE A MEMORY

MIG REYES

www.migreyes.com

Mig Reyes is a freelance graphic designer from Chicago. He's often engaged in conversations about key frames, motion blur, letterpress, small caps and reasons as to why certain web browsers don't render CSS properly. Before finishing college, his work was recognized with Adobe, AIGA and Rockport Publishers. His good vibes continue to roll as he has contributed to *CMYK Magazine*, Scott Hull's Visual Ambassador (http://visualambassador. com) and Speak Up and has taken active roles in plenty of other design communities. Mig doesn't care much for awards or recognition though. In addition to expanding his creative palettes, Mig has a passion for helping other young-gun creatives find their own successes, too.

"Creative Meat," a poster for *CAKE* Magazine by Mig Reyes.

66 I was a bit apprehensive in learning that my creative task was to "Illustrate a Visual Memory." I've never considered myself a good illustrator, but rather, a designer who can create glorified doodles, at best. Nevertheless, in tackling this creative task, I pushed aside what I knew about Photoshop and picked up my trusty Sharpie pen and sketch pad, allowing the doodles to get to work. Thinking back to when I was just five years old, I remember having a vice in the form of soft, chocolate cakes rolled with creamy filling, completely coated in even more chocolate. With mom gone for work and dad still sleeping, I'd run to the kitchen to grab the glorious box of twin-wrapped treats. Yes, I ran for the Ho Hos when no one was looking. With this illustration, I wanted to capture the burst of awesome that hit my mouth each time I snuck in one of the tubular snacks. I embrace collaboration as a necessity in successful creative endeavors. In finishing this illustration, I wondered two things: How did the other one hundred plus artists handle their own creative challenge, and more importantly, do they share that same sweet tooth I have? 99

CREATE A SCULPTURE

SAMIA SALEEM

········· ➤ www.samiasaleem.com

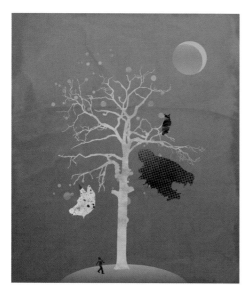

Samia Saleem is a Brooklyn-based interactive designer and the principal of aplural. She has worked for companies large and small, including Organic, Digital Kitchen and Sesame Street. Samia has been featured in *Communication Arts*, *HOW*, *Curvy* and *Design is Kinky*. Her work also includes an award-winning postcard anthology, *Degrees of Separation*, which showcases post-Katrina responses by designers from around the world. She is currently planning several personal projects and taking part in the creation of a design collective.

"Nightmares," a collage and illustration by
Samia Saleem.

> Though I sketch out my plans on paper, I'm a designer who primarily works on the computer. Thus, creating a sculpture was a serious change of pace and a challenging task. I was unfamiliar with the medium and the materials that sculptors deploy to create their works, but it gave me the opportunity to explore in an unconstrained fashion. Recently, when I visited the Bronx Zoo, I was struck by a lone polar bear who endlessly paced back and forth. While most of the visitors were delighted by the fact that he was simply moving, I found it absolutely terrifying because he showed such degeneration in captivity. Using papier-mâché, tinfoil, tissue, cardboard and paint, I created my masterpiece. It portrays his loneliness, but it also exhibits a sense of hope because he is at peace with himself. While this may be a blind hopefulness because its species, along with countless others, are threatened with total annihilation at the hands of climate change, I hope against hope that it is not.

DESIGN A SKATEBOARD

CAROLE GUEVIN

http://netdiver.net

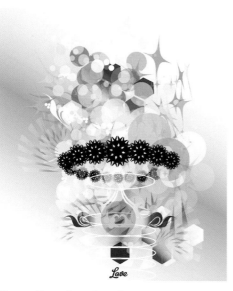

"Sunny Barcelona," self-stock photography and illustration by Carole Guevin.

Carole Guevin is an experienced communication designer, new media pioneer, theorist, philosopher and founding partner of Feed Your Eyes creative continuum and the publisher of Netdiver, an online digital culture magazine. She is an internationally recognized driving force and unrelenting industry evangelist, activist and catalyst through her work as editor; she champions the love of design worldwide, online and beyond. She is often invited to judge international design competitions. She has served on the Adobe Design Achievement Award, HOW Interactive Design Awards and SXSW Interactive jury, as well as on many others.

"[My] most important [finding was] that skateboards had been exploited and explored as media for self-expression and for adorning known brands by all walks of artists and designers. This notion in itself inspired, humbled, scared, challenged, thrilled me all at the same time. And the thought of designing one, threw me in self-doubt more than not. I chose the creative perspective of an artist, and with the freedom afforded by self-expression, I began to accept the weird shaped canvas and run with it. Finding a suitable, full-size template turned out quite daunting. One would have thought that it would be readily available. Well it was not. After trials and errors, I finally built a clean Illustrator template and started experimenting. I had ten different designs going at some point and enjoyed every minute of it. I picked this one, which mixes a street shot I took in Barcelona and uses bold, black graphics with a gradient color treatment to complete a somewhat edgy urban feel (well I like to think it does)."

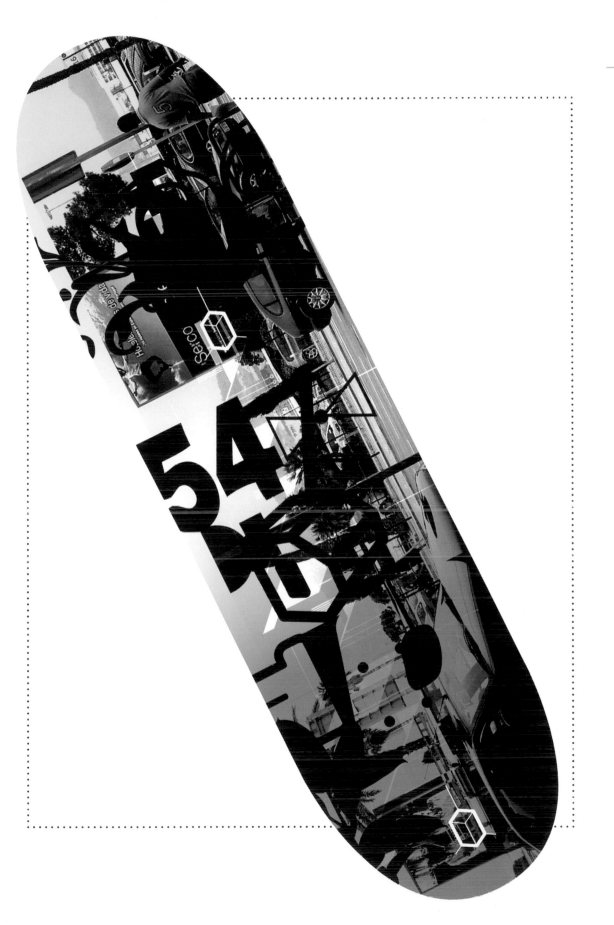

DESIGN A CHARACTER

SEBASTIAN LITMANOVICH

············▶ **TEA TIME STUDIO**
www.teatimestudio.com

Tea Time is a creative studio based in Barcelona, Spain, directed by Sebastian Litmanovich, who works on graphic design, art direction, branding, packaging and magazine design projects. Some of his present and past clients are: ESL Music (United States), Iori Hotel (Japan/Spain), Houynhnhms.tv (Spain), the fashion events Circuit and ModaFad (Spain), the shoe company Wonders (Spain), *Rojo* magazine (Spain), Avalancha Studio (Spain), DDB agency (Spain), Arte Viva Foundation (Brasil) and FCB Worldwide (Argentina). Sebastian has had other projects like Cineplexx (http://cineplexx.net) and Cacahuetes Inc. His work has also been performed at the Lowlands Festival (Holland), Sonar Festival (Spain) and Netmage festival (Italy).

Branding design for Iori Hotel, Resto & Shop (logo, stationery, poster, illustration and website) by Sebastian Litmanovich.

"I really enjoyed doing this task; it's a great concept for a book actually! At first, I misunderstood the task because I thought that "character illustration" means doing illustrations using character forms, just as you can see on Iori Hotel icons, so I thought that I was being asked to go in this direction! Finally I decided to go in this wrong direction, creating two characters based on two of my all-time favorite fonts, so I'd imagine an everyday conversation between these two fonts while they are having a teapot, of course. I really enjoy writing the dialogues. This can become a series of teatime conversations! Look out for more soon!"

A lovely tea time with:
American Typewriter & Helvetica Neue

- ¿More tea?

- Oh! You are so gentle & elegant... ¿ Is it okay if I speak in italics ?

- ¡I love italic accent!
I was wondering, how do you get so heavy? you know, I have problems with fat so I have to take care of my shape, if not people can't read me very well...

- Well, I started with bold shapes, and I had really great feedback, you know, I felt a little unreadable at first but, in some situations I can be **bold**, or **heavy**, and everybody seems to like it, so, I keep going and going... you know.

- Yeah.. I know, but I became "kind of known" with my light shape, so everybody wants the "hits" all the time, and I remember I thought, "well, yeah, I am an entertainer, so, let's give'em what they want!"

- yeah... absolutely! but it's important to keep the line, you know what I mean ? Or you can become the new Comic Sans !!!

- OMG !!! God save me from that remote possibility!!! Or become a Trixie!!! and be forgotten just like a one hit wonder, no no no...

- No man, you really have to take care to avoid becoming a Trixie, after all family is family, and there are genes and this things....

- yeah, but don't worry, I did a Fontographer test the other day and it looks like I am okay, so... Did I tell you about these Fontographer tests they are doing for free? Interesting; they found a little kern thing, but nothing serious really...

- well that's what happens to "the classics" like us, we have to take care of designers and hyphanations...

- And Paragraph Justify!

- Absolutely! Paragraph Justify is a real mess sometimes! Designers should get a license to use it!

- ¿ More cookies ?

- Yes, please.

DESIGN A CHARACTER

JACK CROSSING

www.jackcrossing.com

DOCTOR MY EYES
THE UNIVERSE IS IN MY BACKYARD

The Universe Is in My Backyard CD sleeve
for Doctor My Eyes by Jack Crossing.

Jack Crossing was born in 1987 in Surrey. He has wanted to be an artist for as long as he can remember. After experimenting with various disciplines, he decided to specialize in graphics. He went to the University of Bath in 2005 and graduated with a first class degree in graphic communication in 2008. Jack is now seeking employment in London and is currently undertaking a number of work placements in agencies. Jack has been influenced by a vast number of individuals in both illustration and graphic design.

> " Having always been inspired by illustration as well as graphic design, I found my creative task one which I enjoyed a lot! It was a lot of fun making the character and putting him in different situations. I think the task itself, overall, could have been overwhelming, but fortunately for me, it was a lot fun. I hope everyone else enjoyed their tasks as much as I did. "

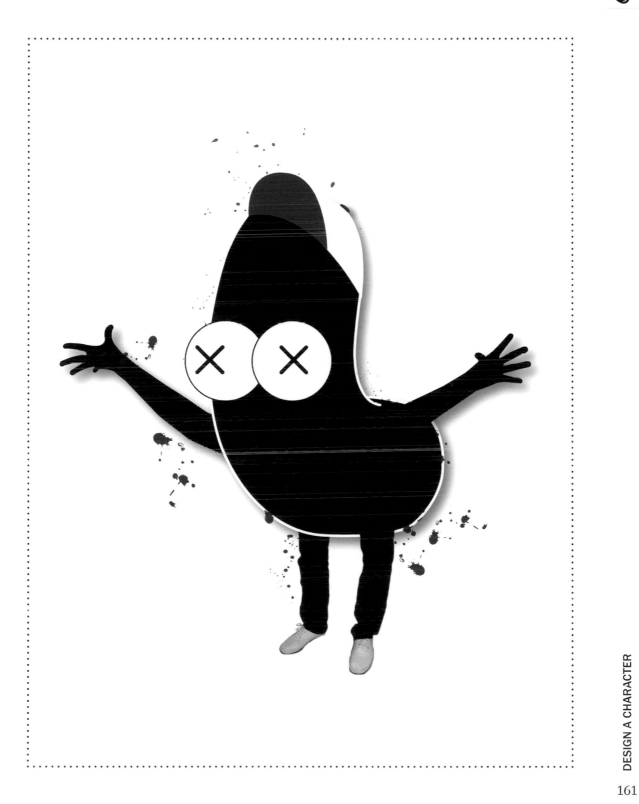

STEVEN M. ILOUS

www.stevenmilous.com

Steven M. Ilous was born the same day the Vandals plundered Rome in A.D. 455. Even though it has been some time, he is still considered a prime suspect. In between running from the Romans, he has found the time to professionally pursue screenwriting, directing, executive producing and to explore VFX supervision, performance capture technology, photography and illustration. Steven currently lives between Prague and Los Angeles and is managed by John Jacobs of Smart Entertainment.

"Untitled Girl," an illustration by Steven M. Ilous.

Before I began to work on "Chroma," I took a step back and asked myself, "What is wallpaper?" and "What is gift-wrap?" How do I change something that has been around for millions of years? And then, it dawned on me, like the first time man made fire, make it 3-D. Everyone loves 3-D, even dinosaurs. This piece was designed to utilize ChromaDepth, a new 3-D technology that allows you to encode depth into an image by means of color, and then decode the color by means of optics, producing a true, stereoscopic, three-dimensional image. It has truly been an honor to be part of this book with such a wonderful collection of talented artists. Thank you Ethan Bodnar and F+W Media.

MARC JOHNS

www.marcjohns.com

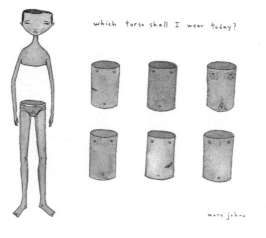

which torso shall I wear today?

marc johns

"Which Torso Shall I Wear," a drawing by Marc Johns.

Marc Johns creates deceptively simple drawings filled with wit and humor. He's been drawing since he was tiny. He's not tiny anymore, but he's not exactly big either. He likes to create absurd situations by combining things that don't belong together or imagining what inanimate objects would say if they could speak. For instance, his pen might say: "I can't believe you're making me write this—it's crap." This way of thinking can be hard to manage, and he doesn't really recommend it. But he can't help seeing the preposterousness and humor in our world, which often helps him find a truth of sorts.

" When I received my task to create a brand and a logo, I was pretty excited because taking a critical look at marketing and branding is something I love to do in my work. I chose myself as the brand, because what better brand to poke fun at than myself? The commodification of the artist fascinates me, so the chance to explore it in this way was amusing. I hope I've amused you as well. The logo is hand-drawn. My name is written in the same manner that I sign my work. What often lends a piece of art its value is the artist's signature; it is a mark of authenticity. The scribbled blob in my logo represents every drawing I have ever made, stacked on top of each other. In this logo, I have given everything: my name and all of my work. Despite its simplicity, nothing has been left out. "

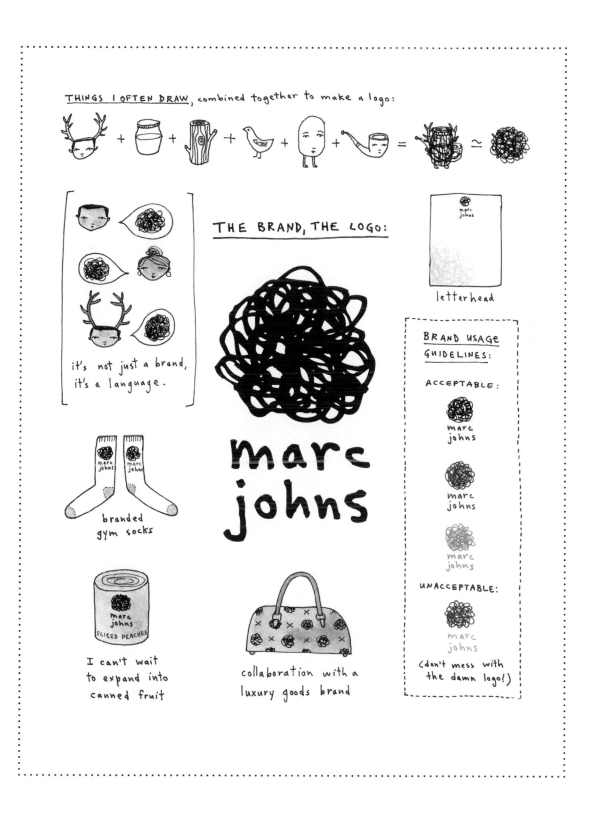

THINGS I OFTEN DRAW, combined together to make a logo:

THE BRAND, THE LOGO:

marc
johns

it's not just a brand, it's a language.

branded gym socks

I can't wait to expand into canned fruit

collaboration with a luxury goods brand

letterhead

BRAND USAGE GUIDELINES:

ACCEPTABLE:

marc johns

marc johns

marc johns

UNACCEPTABLE:

marc johns

(don't mess with the damn logo!)

DESIGN A BUILDING

SARAH COFFMAN

www.minus-five.com

"You Can't Know The Bridges You'll Need Before You Burn Them,"
a painting by Sarah Coffman.

Sarah Coffman is a designer and an art director. She attended the Portfolio Center in Atlanta, Georgia. Upon graduation, she made it as far as Dallas and got a job as an art director. Then she felt that her life was no different than that of a seventy-three year old, and she felt that she had settled, and this scared her. So she quit her job and bought a one-way ticket to New York. She has since lived off of freelance and luck in Brooklyn, in a quiet neighborhood with some trees, some lampposts and barely any rats.

" The seventy-nine photographs were supposed to be made into postcards and mailed to friends, but that was four years ago, so instead of leaving them to collect more dust, I used them to construct different shapes to build a picture of lessons I've learned since deciding to move to New York. The shots were all taken during the weeks preceding my move and throughout my first months in the big city. During that time, I tried very hard to put everything in order and do everything right and to stand up straight and to be good and to make perfect every edge. And then the wind would come and knock it all over. And I'd try to put it back together as I thought it should be. And again, the wind. In a rare pause, there came perspective, and with that, the realization that the imperfectness was beautiful and that the wind blew everything exactly where it should be. "

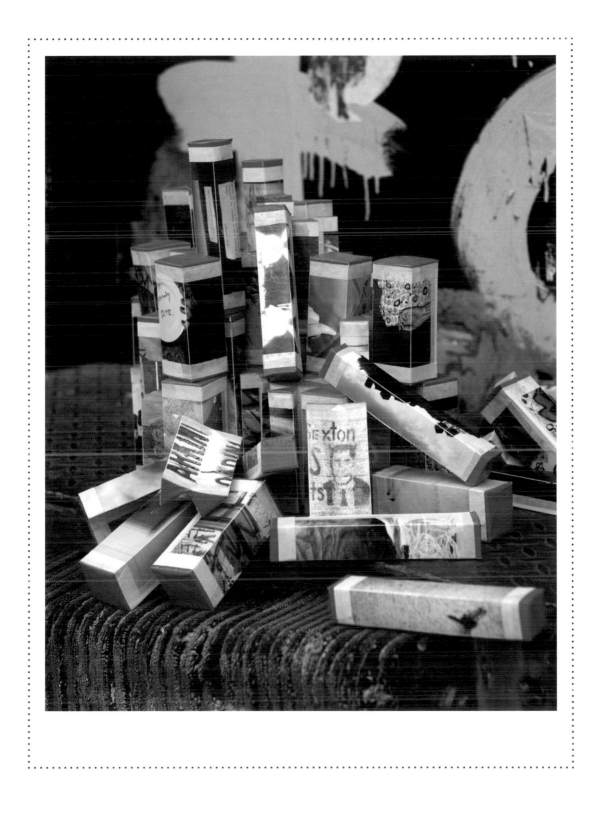

BOB BORDEN AND DUANE KING

············> BBDK www.bbdk.com

100% Soda packaging by Duane King.

Bob Borden is BB. Duane King is DK. Bob and Duane formed a multidisciplinary studio called BBDK. In 2008, Shane Bzdok joined BBDK. From their home office in Santa Fe, New Mexico, and satellite office with the design studio Athletics in Brooklyn, New York, they collaborate with a network of graphic and product designers, programmers and photographers worldwide. Duane's first computer, a Commodore 64, fueled his self-taught technical knowledge and set his passion for wondering why into motion. Duane develops design solutions for brands. He has been responsible for the conceptualization, management and production of all forms of visual branding including interactive, print, packaging and both e-commerce and brick-and-mortar stores.

" We approached our assigned creative task in the same way that we approach our daily projects, with a sense of playfulness and curiosity combined with a healthy dose of experimentation. Once it was determined that our task was painting, we instantly started daydreaming about how to reinterpret the assignment. It wasn't long before our thoughts drifted to memories of peeling glue off of our fingers in grade school and the process for our task was born. We ended up CNC routing the word *Paint* in reverse into HDPE plastic to create a 15" wide mold that we slowly poured puddle after puddle of latex paint into. We took the concept of grab bag and applied it literally to our paint selection—we bought whatever was available from the collection of discounted, rejected mixes of paint at our local hardware store. Operating off the universal law that oil (HDPE) and water (latex) don't mix, we moved forward. The latex paint was easily removed from the mold revealing the dimensional type and voilà! The casting is so detailed you can see the texture of the HDPE surface and the tool marks from the CNC router. "

CREATIVE GRAB BAG

168

DIGITALLY MANIPULATE A PHOTOGRAPH

ALEX OSTROWSKI

www.alexostrowski.com

"The Happiest Book in the World" by
Alex Ostrowski.

Alex Ostrowski is a graphic designer and illustrator who graduated from University of West England in Bristol. He is currently gaining work experience at a number of places in London, such as the Guardian, thinkpublic and YCN. He uses his design for good, applying his thinking methods to things in order to benefit them. He values clarity and succinctness of communication, based on a dichotomatic cocktail of play and logic. He likes using and appreciates the ability of personality to communicate a message in an engaging way. His goal is to create exceptional communication that looks just as exceptional, if that's not too much to ask.

" I decided to create the most arresting visual I could conjure for my creative task, since it would appear among others in this book. As with most things, I tried to approach this challenge in the most direct and transparent way possible. On a bus journey one day, I noticed the absolute clarity and distinction of the stop sign used to ring the bell and request that the bus stop. I took a photograph and thought about how I could use an illustrative intervention to accentuate its impact further still. While it may seem obvious, a few hand-scrawled arrows quickly combine a personal sense of urgency with the authority of the information-based sign "stop." This play between authored and unauthored visual elements is something I like to explore, as both ends of the spectrum have opposite but equal significance to the eye. "

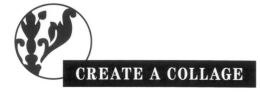

Pablo Alfieri is a graphic designer and illustrator born in 1982 in Buenos Aires, Argentina. In 2002, he started the career of graphic design in the University of Buenos Aires, where he discovered his passion for design, illustration and typography. In 2008, he created Playful, a showcase of his personal works: a free space where he plays and has fun with colors, typography and geometric shapes—the basis of his creative work.

"Design in Love," a poster by Pablo Alfieri.

“ It was a great experience to explore new ways to express myself and learn about other techniques. I can't wait to see how other artists could explore the different creative tasks. My task was collage so I want to surprise you with my own little grab bag … Body, Soul and Rock 'n' Roll! ”

DESIGN A TYPEFACE

JONATHAN KROHN

www.jonathankrohn.com

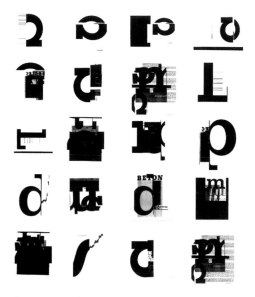

An excerpt from "Burying the Future With the Past" by Jonathan Krohn.

Jonathan Krohn earned a master of fine arts degree in design from the University of Illinois, Chicago. He currently lives and works in Chicago, where he is also the co-frontman of the music project, Male, which released its debut LP earlier this year. In his spare time, Jonathan enjoys "takin' it easy" and swimming. As his dad once asserted while searching through a deceased relative's box of ephemera, "That's where Johnny gets his art from."

> I chose to create Face 1 out of the need to develop a typeface in a relatively short amount of time. Due to the nuances of each individual letterform, numeral and symbol, the art of designing a typeface can take years. I purchased a new computer at the beginning of the summer, and in the three months since, I have not begun to add all of the typefaces that are usually required after such a purchase. Using the letters A–Z in all capitals, I superimposed every typeface that was preloaded onto my machine; this is the result.

CREATIVE GRAB BAG

174

CREATE A COMIC STRIP

ISABELLE GEHRMANN

www.isabelle-gehrmann.de

Isabelle Gehrmann, born in 1979 in Kaiserslautern, Germany, is a graphic designer and art director. She works across various media: from books, posters, illustrations and typefaces to corporate designs and identities. After her final high school examination in 1999, she studied architecture at the University of Kaiserslautern. In 2002, Isabelle moved to Mainz, Germany, to study graphic design. She graduated at the University of Applied Sciences Mainz in July 2007. In 2005, she founded the design studio A Hundred Dollars and a Dog with graphic designer Stefan Ruetz. AHDAAD is a studio for graphic design and art direction that focuses on art, culture, fashion and architecture.

Exhibition poster series for Galerie an der Pinakothek der Moderne by Isabelle Gehrmann.

My creative task was to draw a comic strip. So first of all, I did a wide research for the comic strip in history. On my search, I finally came across Sir Conrad MC STRIP (comic strip). This portrait is the only existing proof of the precursor of this colorful species. The species of MC STRIPS has passed through an enormous evolution till today and doesn't exist in its original form any more.

DESIGN A POSTER

CHRIS JUDGE

www.chrisjudge.com

Chris Judge is an illustrator and painter based in Dublin, Ireland. When he is not relaxing by his pond, he can be found doodling and making a terrible mess in his studio. He is also a fine entrée chef and horse wrangler.

"Facez," a poster by Chris Judge.

"I spent years trying to define a style that was my own, only to find I couldn't identify one, and that scared me. In a moment of enlightenment, about two years ago, I realized I can draw whatever I want, and it opened up a whole new world to me. So when I'm exploring a new project I have a much greater sense of freedom.

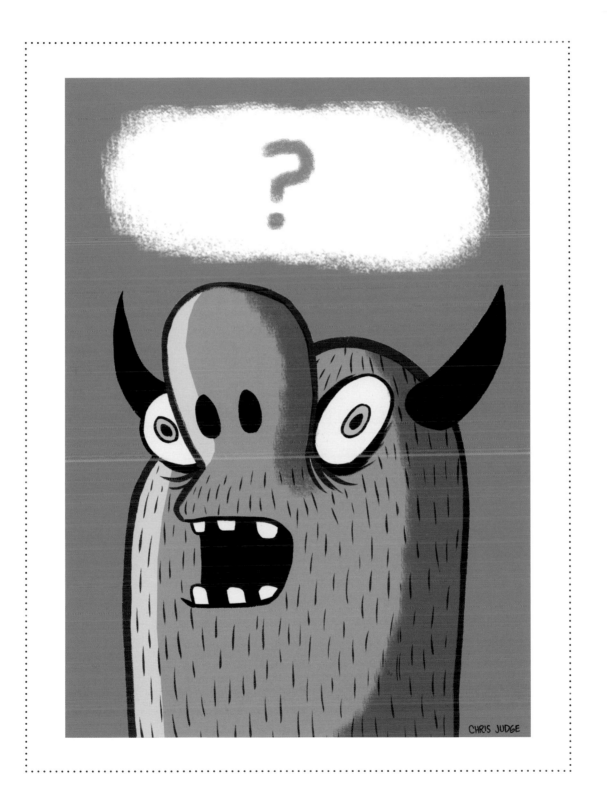

CREATE AN ILLUSTRATION

SCOTT BARRY

SACRED MTN.
www.sacredmtn.com

"Boogie Beach Days," ink on paper by Scott Barry.

Scott Barry is an illustrator/designer who has worked with a wide variety of clients including MTV, Nieves, Nike and NYLON. He has exhibited internationally, including recent exhibits in San Francisco, London, Paris and Copenhagen. He currently lives and works in San Francisco.

"I've been taking a lot of walks and bike rides. Sometimes, I go to the pie shop. I'm easily distracted and really into procrastination. I do a lot of concepting in the shower. I've been spending my mornings sketching ideas for whatever projects the day holds. Then when it comes time to sit down and work, the idea is already there and you just fill in the blanks. I don't check many design blogs or read too many magazines. If I do see something I like, I've had a new philosophy of not bookmarking or buying it. So when I try and recall it later, in the studio, all I'm left with is the hazy memory of what I can remember I liked about the piece. I often get consumed in Flickr and Google images. I'm definitely inspired by my surroundings. I move away from San Francisco every summer and live in a city I've never lived in before. It helps me to get away from routine. I try not to clutter my work with social and political commentary. I try to live by simple philosophies. If my work makes one person smile a day, then I'm happy."

180

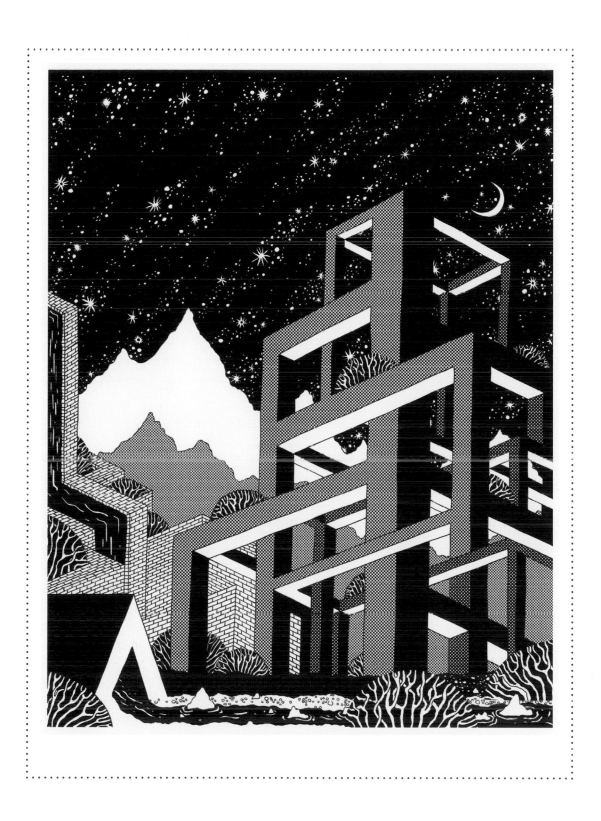

SCOTT BUSCHKUHL

HINTERLAND
www.hinterlandstudio.com

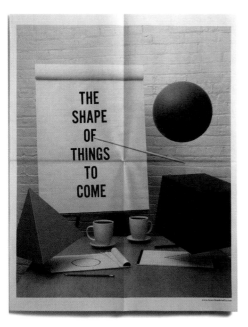

"Before & After" by Hinterland.

Hinterland is a multidisciplinary design studio founded in 2003 by Scott Buschkuhl and based in Brooklyn, New York. Hinterland believes that the best work comes from a close collaboration between client and studio. They have a passion for solving design problems. Their client list includes *The New York Times*, *myhouse* magazine, New York Law School, Simon & Schuster, the American Museum of Natural History, Time Inc. and W.W. Norton & Company. Their work has been honored by the Art Directors Club, the Type Directors Club, Folio: Show, Print's Regional Design Annual and the American Institute of Graphic Arts 50 Books/50 Covers show.

"This imaginary magazine cover is an homage to the British publishing industry combining ideas, both past and present. The self-imposed goal was to re-imagine The Gentleman's Magazine from the eighteenth century for the present day, joining content from the past with visuals of today that embrace the high fashion lifestyle sought after by sophisticated gentlemen in 2009. This book was a wonderful way to get the creative juices flowing. The task Hinterland was assigned for this book was predominantly a commercial one due to the nature of what a magazine cover can and should be. Therefore, I was able to play the role of client, editor and creative director which might appear to be a dream project for some, but to be honest, I benefit from structure, short deadlines and someone else's puzzle to solve. The main question I had was would it still be a magazine cover if it did not address specific newsstand issues such as logo, headline placement, cover lines, price, date, UPC symbol, etc.? In answering this question, I believe I was much harder on myself than any typical client-studio relationship."

tgm

The Gentleman's Magazine
Volume. 277
Issue. 01
Established
January
MMCCXXXI
London

*HOW TO PULL
OFF A PETTICOAT*

**SAVAGE THOUGHTS
IN MODERN TIMES**

*THE 7 HABITS
OF HIGHLY
SUCCESSFUL
NOBLES*

**CORRESPONDENCE
WITH SYLVANUS URBAN**

*GREAT NEW WIGS, TOP HATS
AND UMBRELLAS*

UK £6.00
USA $11.00

ISBN 1-44631-9371

DESIGN A MAGAZINE COVER

183

CREATE A COMIC STRIP

JASON TSELENTIS

www.morsa.com

In the design field, Jason Tselentis is a practitioner, educator, critic and advocate. His print and interactive clients have included the Experience Music Project and Science Fiction Museum, Intel Labs, the National Park Service, Sony BMG Music and 20th Century Fox. Jason has consulted design studios to help them improve their operations and marketability. He's written for the award-winning design forum Speak Up, and his writing has appeared in magazines such as *Arcade*, *Emigre*, *Eye*, and *HOW*. He teaches graphic design and typography as an assistant professor at Winthrop University in South Carolina. He dedicates his after hours to writing short stories and developing screenplays.

"Bark with the Big Dogs," a poster for AIGA by Jason Tselentis.

" When I was invited to participate, I had reservations because I somewhat feared the grab bag project Ethan would assign me. What if it was out of my comfort zone? What if its scale and scope were unattainable? When I received the comic strip assignment, I was both relieved and excited because I have always been a comic book fanboy. It's as if Ethan read my mind. For the project, I wanted to focus on the story more than the rendering tactics, and the resulting geometric Illustrator drawing is my attempt to downplay how the comic looks. Yes, the narrative and rendering play off one another, but I didn't want to lose myself, nor the viewer, in the aesthetics. I enjoyed the project from start to finish, and would do it again—a comic strip that is. Up until the end, I asked myself, "Could I do this full time?" And the answer is a resounding "Yes," but the question that still remains is, "Should I quit my day job?" "

JOHN MARTZ

www.robotjohnny.com

"Private Dickie," an illustration by John Martz.

As a child, John Martz spent most of his time drawing cartoons, reading books and living in emotionally unhealthy fantasy worlds. As an adult, he is somewhat hairier. John lives in Toronto, Canada, where he works from his home as a cartoonist and illustrator. His work graces the pages of kids' magazines, greeting cards and web sites. He blogs about his life and career under the alter ego of Robot Johnny and also acts as the editor of the popular cartooning and illustration blog, Drawn!

"My first step was to come up with a band name, and I immediately thought to go with some sort of insect. Initially, I thought I'd tackle this assignment using photography, since the idea was to stretch new or unused creative muscles, but then I figured I shouldn't veer too far from my main skill set, and I wanted to use this opportunity to think about illustration in a way that I normally wouldn't. Designing as if for an album cover forced me to use illustration in a far simpler and design-oriented way, inspired by silkscreened gig posters and graphic illustrated jazz records. Once I had the band name chosen, the idea to combine an anthill with a volcano came fairly quickly after I started working out ideas in my sketchbook. The idea seemed so perfect and simple that it all came together rather effortlessly."

PAUL STONIER

www.paulstonier.com

Paul Stonier is a young graphic designer. He writes for his blog, the type nerd, which he uses to provide himself and his peers with a resource of design that is not only interesting and worthy, but that serves a role within culture. As a recent graduate of the Rochester Institute of Technology School of Design, he takes influence from a plethora of sources. Most recently, he's been looking into neuroscience to apply his understanding of perception into his design. Some of his favorite people include Marian Bantjes, Michael Bierut, Debbie Millman, Grant McCracken and Jonah Lehrer.

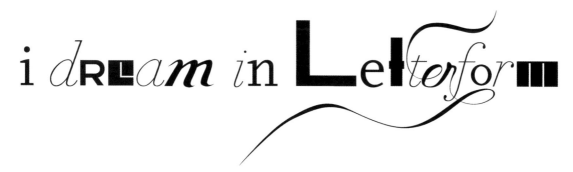

"I Dream in Letterform," modified/custom lettering by Paul Sonier.

> Eating food is an act that engages all of the senses. It is often understood that the presentation of the food can shape how much you enjoy your meal. Therefore, in choosing the subject matter of food to represent senses, I decided to use words that reflect not only that sense but also part of the experience. I was glad to have the opportunity to work manually with food to create letterforms. Ever since I was introduced to the Manual Pixelism project done at ÉCAL and the Marian Bantjes/Stefan Sagmeister sugar project, I've been dying to get a chance to work in such a way.

CREATIVE GRAB BAG

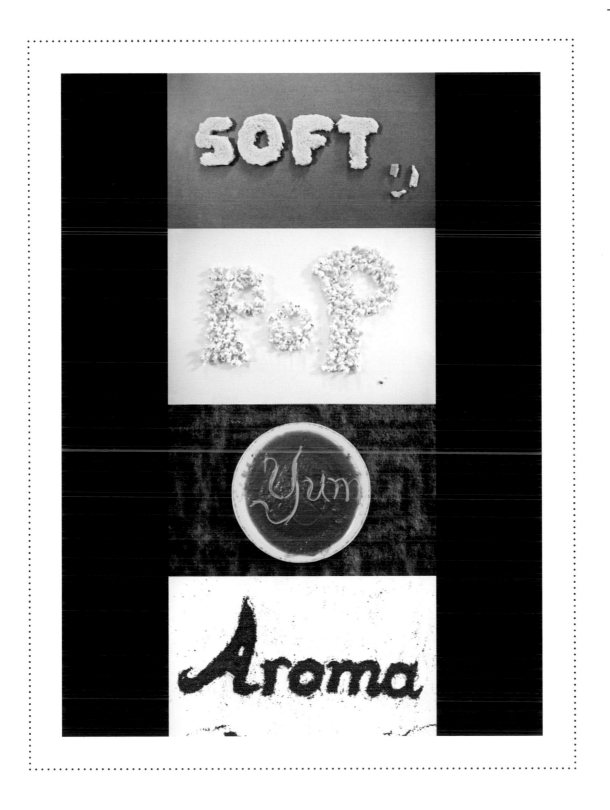

DESIGN A BUILDING

JULIANA PEDEMONTE

COLORBLOK, INC. www.colorblok.com

"Hanging at the Park," a gocco serigraph print by Juliana Pedemonte.

Colorblok founder Juliana Pedemonte's illustration and motion graphic work has been regularly appearing on VH1 Latin America, MTV Latin America and Nickelodeon since 2003. Her work echoes a happy creative childhood. Born in Bahía Blanca, Argentina, she remembers growing up with a pencil in hand. She attended the University of Buenos Aires graduating with a degree in graphic design from the Faculty of Architecture and Design. Shortly after beginning work as an illustrator, she became interested in motion graphics and looked to this medium as a way of combining her interests in music, animation, illustration, graphic design and storytelling.

" Walking in different shoes is an exciting thing to do. It's a very healthy thing too, and it enriches the dialogue between different areas of art. It was a lot of fun to pretend I'm creating a house, although as an illustrator, I've always thought you are bound to create whole new worlds in a sense. You're dressing your characters, imagining their furniture, cars, trees, pets and whatnot. "

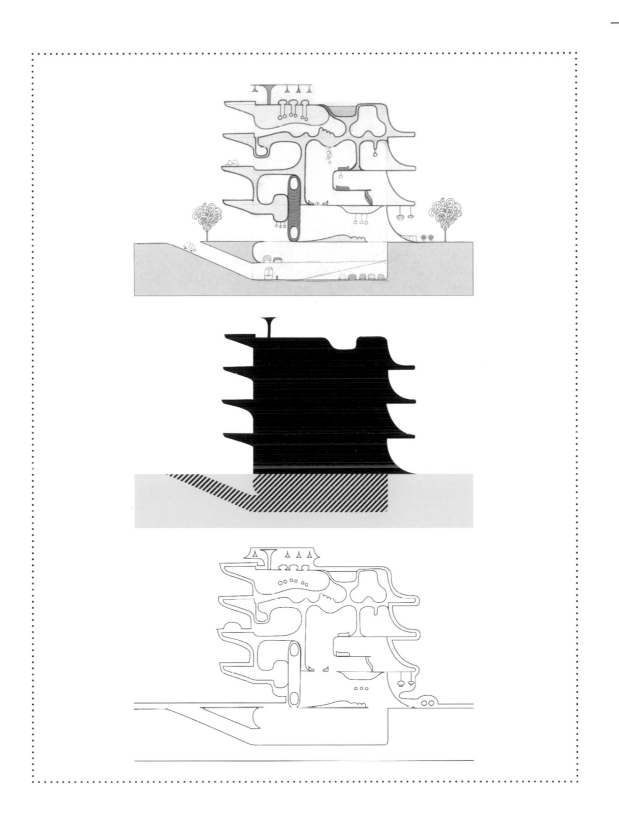

JEFF KULAK

www.jeffkulak.com

Jeff Kulak wonders what life might be like when the gas runs out and the world is run by bicycle gangs. In the interim, he pursues freelance illustration and design from Montréal, Canada. Freshly immigrated, he is adapting to the life in the belle province by eating too much cheese and speaking his own ugly brand of pidgin French. He would like to extend his thanks to Oliver for marching around in a field with a piece of cardstock tied to his face to facilitate these photographs.

"Cinemathon," an illustration for *Vue* Magazine by Jeff Kulak.

> The oldest portrayal of a human face was recently discovered in a cave in France. At twenty-seven thousand years old, the simplistic but sufficient depiction of eyes, nose and mouth precedes the written word and emphasizes that people have been producing images of themselves for a really, really long time. Rather than going about creating an imprint of a specific individual, like a celebrity, politician—or worse—myself, I decided to explore a more contemporary usage of the word as found in the print dialogue of most computer programs. Each time a user selects *File > Print*, they are prompted to select a landscape or portrait format in accordance with the dimensions of their onscreen material. In addition to denoting orientation in image reproduction, portrait and landscape also connote two streams of image production. The representation of the human form and the depiction of the natural world each have their own histories and traditions. These photographs attempt to cross the wires of format and content by staging a portrait orientation in a landscape setting, and vice versa.

CREATE HAND-DRAWN TYPE

MARK VERHAAGEN

www.markverhaagen.com

Mark Verhaagen is an illustrator and animator living in the Netherlands. His work features colorful robots, hairy characters riding big bad motor machines and little marshmallow men living in magical forests. When not working on commissions, Mark likes to keep in shape by making personal work, going out with friends and family and shooting pictures with his Holga camera. Clients include MTV Networks, Vodafone UK, *Computer Arts* magazine, Air France-KLM, Amsterdam Historical Museum and Nickelodeon.

"Mushroom Tree," an illustration by Mark Verhaagen.

" Clients often ask me to make work in my specific style, which is great of course, but it doesn't always show my other capabilities and interests. So I was glad when I was asked to make some hand-drawn typography for this book. I love typography, but haven't used it in my work that often before. So I started drawing letters and sentences in my sketchbook, page after page. I quickly got hooked on it, and found that drawing letters is really addictive! As I'm working mostly digital, I wanted to draw all the letters for my creative task by hand, using a cheap felt pen. I will soon explore drawing letters on my computer as well, as I feel it could be a really nice addition to my current work. "

Will Bryant is a young designer and illustrator and sometimes a deejay. He grew up in the piney woods of east Texas and then learned how to think, see, draw, paint and design at Mississippi State University.

"Nice People Gradient," a hand-drawn type illustration by Will Bryant.

" Working on *Creative Grab Bag* with Ethan has been a dream! He's super efficient and his professionalism is remarkable. My experience with working on patterns was a difficult one. I really wanted to incorporate way too many elements and couldn't nail down the groundwork to hold them. Also, I can't seem to keep my hands clean of color overload, so there was a constant voice in my head saying, "Who would ever want this to be on their wall?" It was challenging, but I'm pretty pleased with the result. **"**

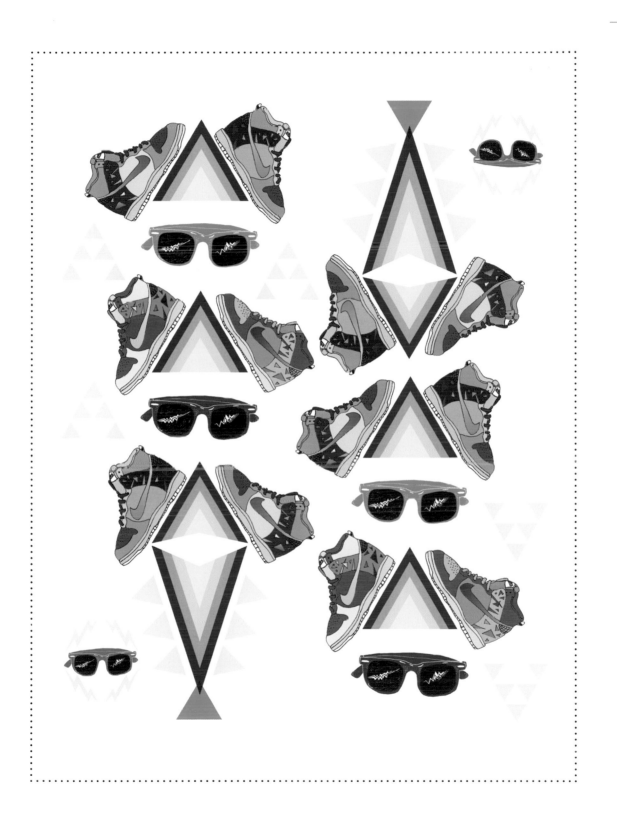

CREATE AN OBSERVATIONAL ILLUSTRATION

NESSIM HIGSON

IAMALWAYSHUNGRY
www.iamalwayshungry.com

"February" for Lounge 72 by Nessim Higson.

iamalwayshungry is the studio of Nessim Higson. He is influenced by Robert Rauschenberg, Tibor Kalman and John Heartfield and endorsed by no one. He believes firmly in the intrinsic value of life; but more importantly, he's always hungry for it. IAAH functions on the core belief of good design equals good business: Design has a responsibility of not only contributing to the economic market but to the social fabric of society. The studio has been recognized in the United States and internationally by *Communication Arts*, *Print*, *Graphis*, the publishing firm DGV (Die Gestalten Verlag), and was recently named a young gun by the Art Directors Club of New York.

> I think when I first approached the task, I thought about it in a very abstract manner. I thought about it in almost a cartoony way. I wanted to do something with humor. But then it occurred to me that I could interpret the assignment in a literal way and actually say something. I've been attracted to very matter-of-fact statements of late. "Tomorrow is Today" and "Forward not Backwards," for instance. They are both very straightforward but grounding at the same time. Hints of positivity. The idea of the book is very refreshing; a required assignment like this is needed for every creative individual. Something to break the daily routine and create something distinctly different.

MAKE A PAINTING

ESEN KAROL

Esen Karol graduated from Mimar Sinan University of Fine Arts, Istanbul, and received her master's degree in communications design from Pratt Institute, New York, where she studied with a Fulbright scholarship. She has participated in several international exhibitions and design events. Her first solo poster exhibition, 48 × 68, took place at Pratt Manhattan Gallery, where she also taught as visiting lecturer in spring 2002. Her posters are in the permanent collection of Museum für Gestaltung, Zurich. She teaches typography and publication design at Istanbul Bilgi University, in the Visual Communication Design Department and works in her one-person design studio Esen Karol Design Ltd. in Istanbul.

Catalog for the 10th International Istanbul Biennial by Esen Karol.

"I had never painted on canvas; I hardly paint anyway. After learning about my task, I went to Bauhaus, the largest hardware store in Istanbul, walked to the hobby section and bought a tiny canvas (24cm × 18cm) and two tubes of acrylic paint: green and white. After my first try, satisfied but still having no idea at all, I went back and bought five more canvases and a tube of black. I decided to dedicate my painting to my chosen colors and titled it: black-green-white. Having not planned the final combination, I painted all [of the] canvases. Somehow, without typography, they looked weird to me, so I numbered them in the order I started to work on them. It took me three days to finish. Finally, they looked so decorative on the wall, I felt a plant from IKEA was needed to complete the composition. It was an immensely relaxing experience. I don't think I would paint ever again in the future."

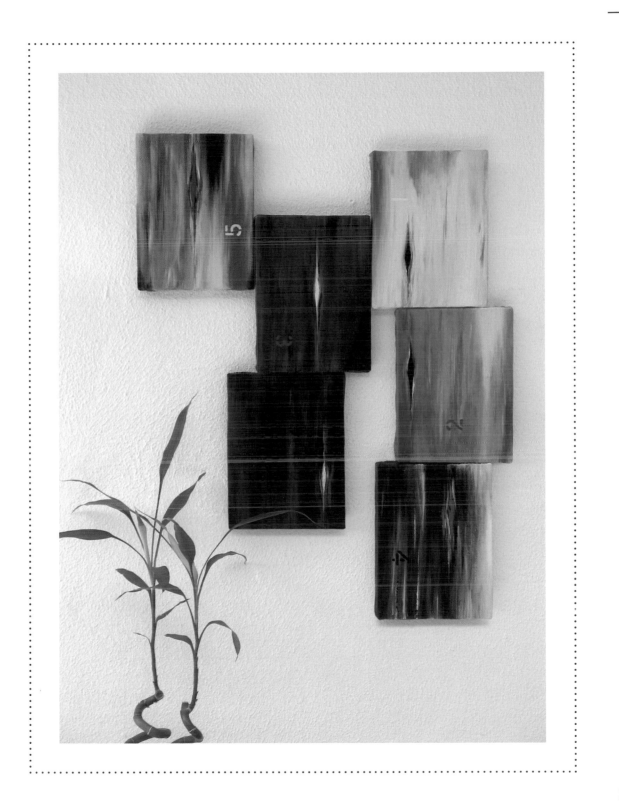

CHRISTIAN LINDEMANN

www.lindedesign.de

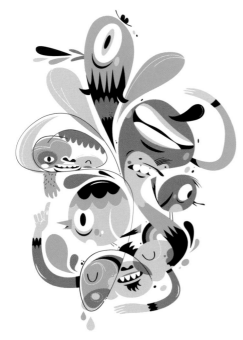

"Monstercloud," an illustration by
Christian Lindemann.

Christian Lindemann was born in 1975 and grew up in northern Germany. He was inspired to take on graphic design and illustration as a result of his lifelong passion for drawings. He works as a freelance illustrator and graphic designer for clients like eBay, DHL, Opodo, Mitsubishi and TNT. His work has been exhibited in Europe and abroad and has appeared in numerous magazines and books. Christian currently works and lives in Hannover, Germany.

CREATIVE GRAB BAG

66 I think the book in general is a great idea. I took the animation task, and it was really challenging to do so. But for me, it was good to explore this new creative field and to push things further. It took some time to get my characters moving, but in the end, it worked. Not perfect, but [it's] a start. 99

You can see Christian's animation at www.ethanbodnar.com/books/creativegrabbag.

202

CREATE A SCULPTURE

J W AND MELISSA BUCHANAN

THE LITTLE FRIENDS OF PRINTMAKING
http://thelittlefriendsofprintmaking.com

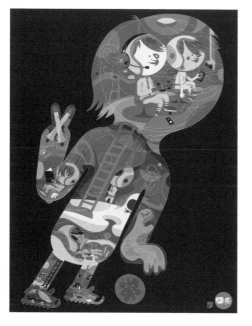

"Inside," a two-color offset illustration for *RE:UP* Magazine by The Little Friends of Printmaking.

The Little Friends of Printmaking are easy to spot—their inky hands and clothes are a giveaway. Their artwork is just as distinctive. Husband and wife team J W and Melissa Buchanan began by designing and printing silk-screened concert posters. In addition to their work as illustrators and designers, they continue their fine art pursuits through exhibitions, lectures and artists' residencies. Their awards include honors from the Art Directors Club, American Illustration and *Communication Arts*. Also, their work has been published in the books *The New Masters of Poster Design* (Rockport), *Two-Faced: The Changing Face of Portraiture* (IdN) and *Handmade Nation* (Princeton Architectural Press).

" We were definitely surprised to be asked to make a sculpture, because our print work is so aggressively flat. We rarely even indulge in the illusion of dimension, let alone actual dimension. It's not our thing. We thought maybe you had something against us, or perhaps you hoped we'd drop out to make room for a more famous designer. Well, tough luck. Here it is. This project required us to call two of our Internet buddies who do this kind of thing, Le Merde and Hello, Brute, and they gave us helpful advice and encouragement. I have to say that this polymer clay stuff is such a pain to work with. My main complaint is that I want it to look way smoother and shinier. And flatter. I'm sure our general lack of skill doesn't help things. We made a point of doing something based (loosely) on one of our print designs, so that we could work out how it would be in 3-D. Surprisingly, it came pretty easily to us. We might do some more of this, maybe in real clay. "

CREATIVE GRAB BAG

204

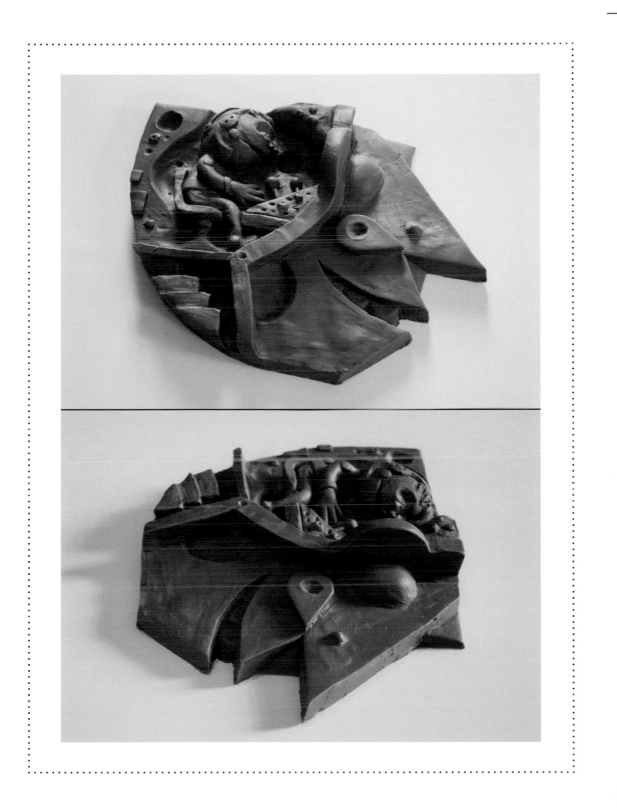

PERMISSIONS

CONTRIBUTOR INDEX

INDEX

MORE GREAT TITLES FROM HOW BOOKS!

Caffeine for the Creative Mind
250 Exercises to Wake Up Your Brain
by Stephan Mumaw and Wendy Lee Oldfield

Packed with 15-minute simple and conceptual exercises, this guide will have readers reaching for markers, pencils, digital cameras, and more in order to develop a working and productive creative mindset.
ISBN: 1-58180-867-4, paperback, 360 p., #Z0164

Caffeine for the Creative Team
150 Exercises to Inspire Group Innovation
by Stephan Mumaw and Wendy Lee Oldfield

An engaging ccompanion to *Caffiene for the Creative Mind*, this book invigorates teams and enlivens brainstorming sessions. The short, focused exercises are designed for groups of different sizes.
ISBN: 978-1-60061-118-6, paperback, 304 p., #Z2194

JIM KRAUSE

The Web Designer's Idea Book
by Patrick McNeil

The Web Designer's Idea Book includes more than 700 websites arranged thematically so you can find inspiration of layout, color, style and more. It's a must-have for starting any new web projects.
ISBN: 978-1-60061-064-6, paperback, 250 p, #Z1756

Creative Sparks
by Jin Krause

This playful collection of rock-solid advice, thought-provoking concepts, suggestions and exercises is sure to stimulate the creative, innovative thinking that designers need to do their jobs well. It will encourage readers to find inspiration in the world around them, spark new ideas and act as a guide to each designer's creative path.
ISBN: 978-1-58180-438-6, hardcover, 312 p, #32635c

BOOKS

These and other great HOW Books titles are available at your local bookstore, from online suppliers and at **www.howbookstore.com**.
www.howdesign.com

THE GRAB BAG CARDS

Now it's your turn to take part in the challenge to explore your creativity. Simply tear out these perforated cards, which will make up your own Grab Bag. Find a hat, bag, bowl or container of some sort and toss all the cards in. Then stick your hand in and grab one, and you'll have your very own creative task. If it's something you normally do, just throw it back in and pick again.

Sit down and get creative with the family, bring it to the studio or office and challenge those you work with, or engage your art class to try something new.

Once it's completed, please send it to **tasks@ethanbodnar.com** and it may be put online to share with everyone at **www.ethanbodnar.com/ books/creativegrabbag** where you can see a gallery of creative work.